EXCURSION:
A BOOK OF ART AND POEMS

By Kimmary I. MacLean

Kimmary I. MacLean

Copyright © 2015 Kimmary I. MacLean

All rights reserved.

ISBN: 1519305540
ISBN-13: 978-1519305541

DEDICATION

This book is dedicated to the many friends and family that have always believed in and encouraged me. For all of the phone calls, emails, text messages, and visits when I was told "You can do it."

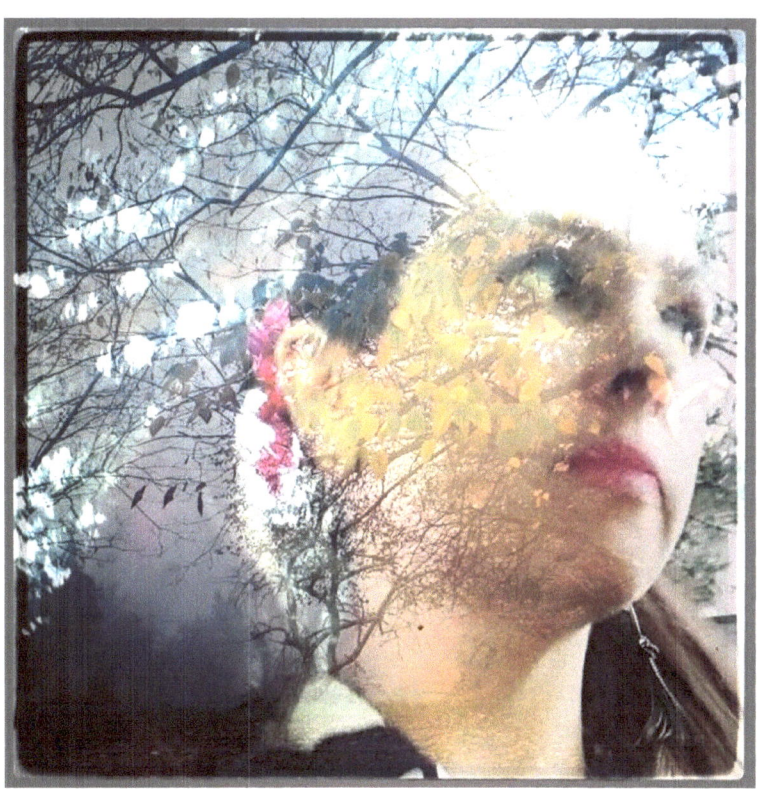

ANOTHER WORLD

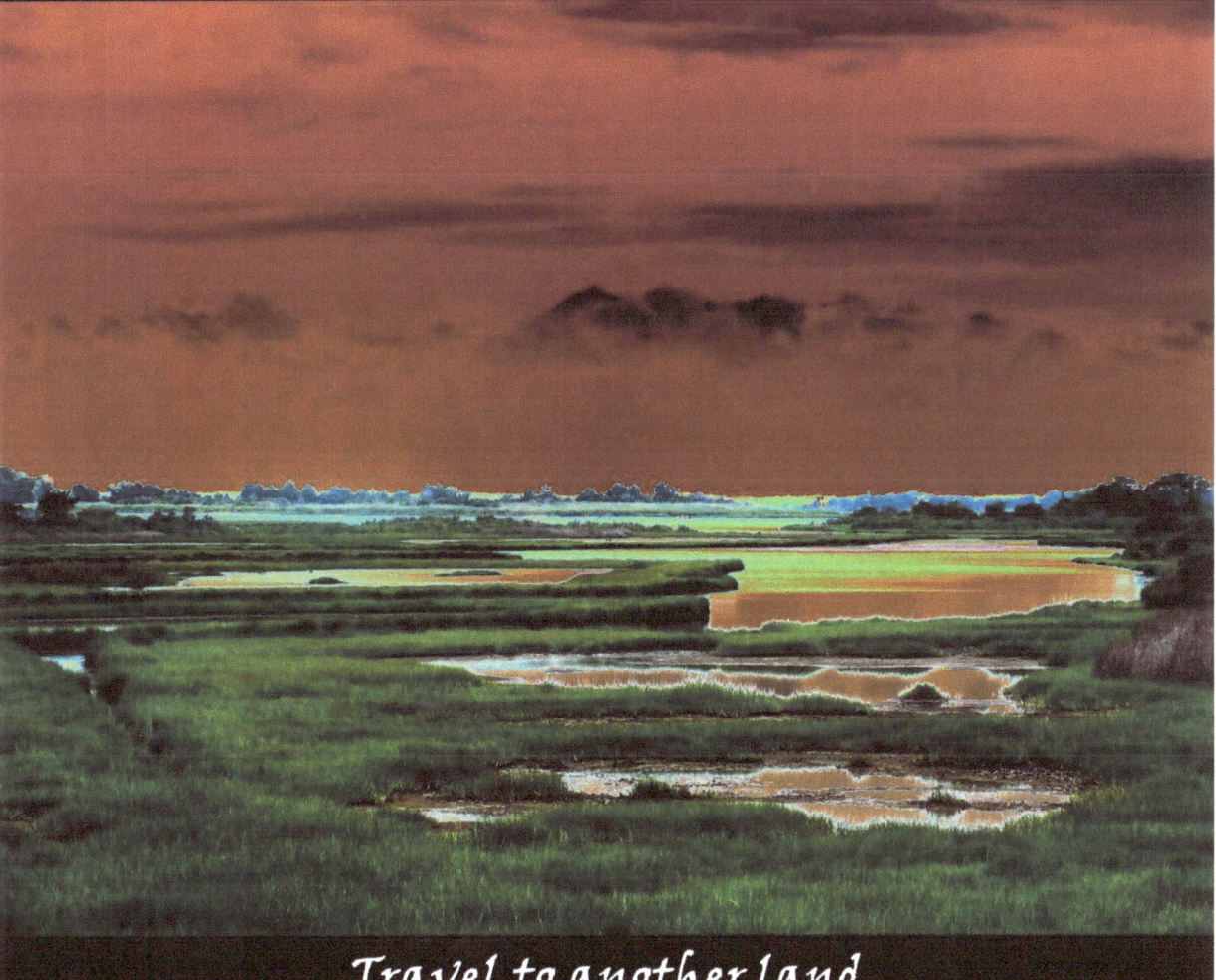

Travel to another land
Another place to learn and understand
Mysteries and wonder await
Another world, another state.

BECAUSE

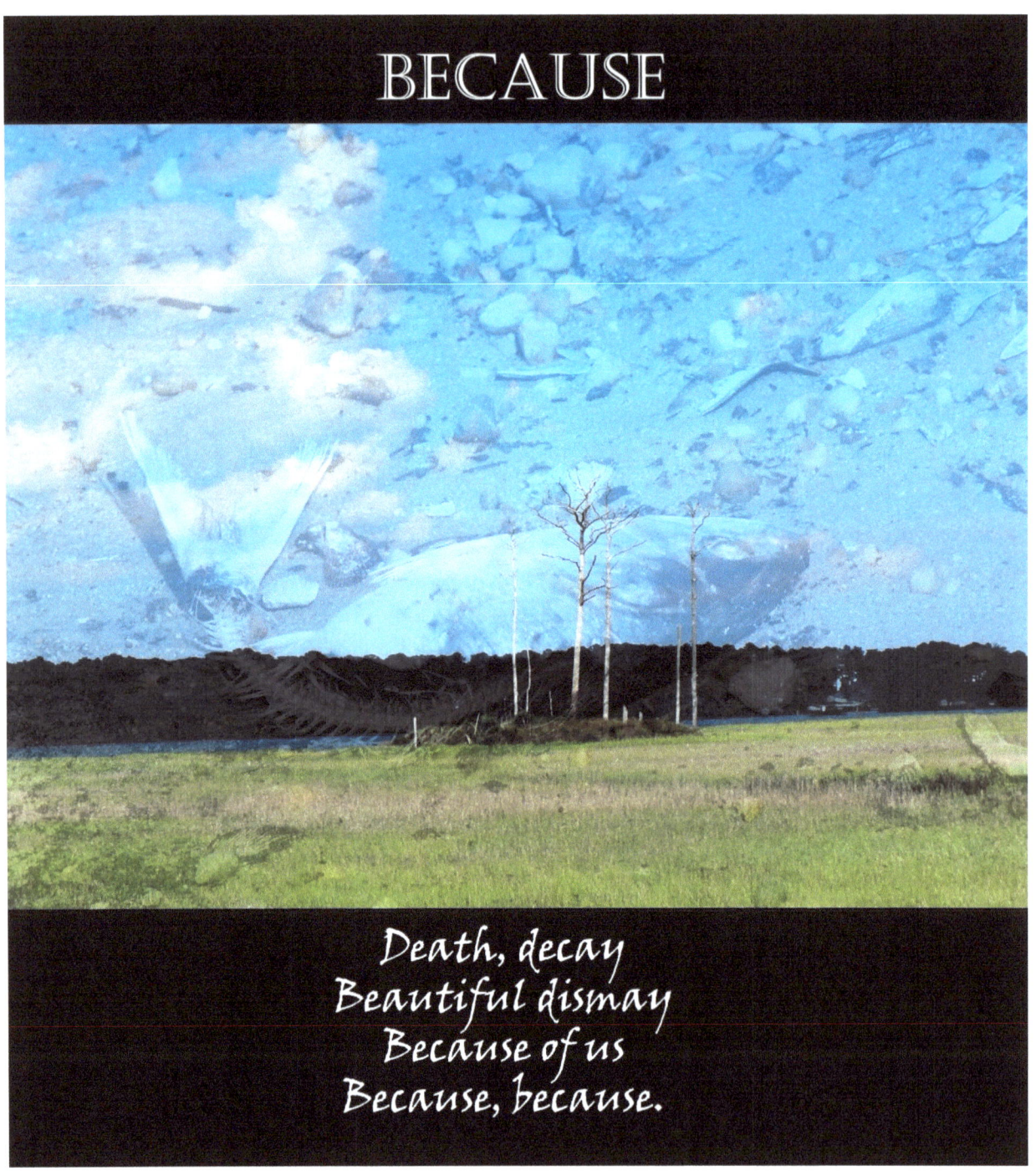

Death, decay
Beautiful dismay
Because of us
Because, because.

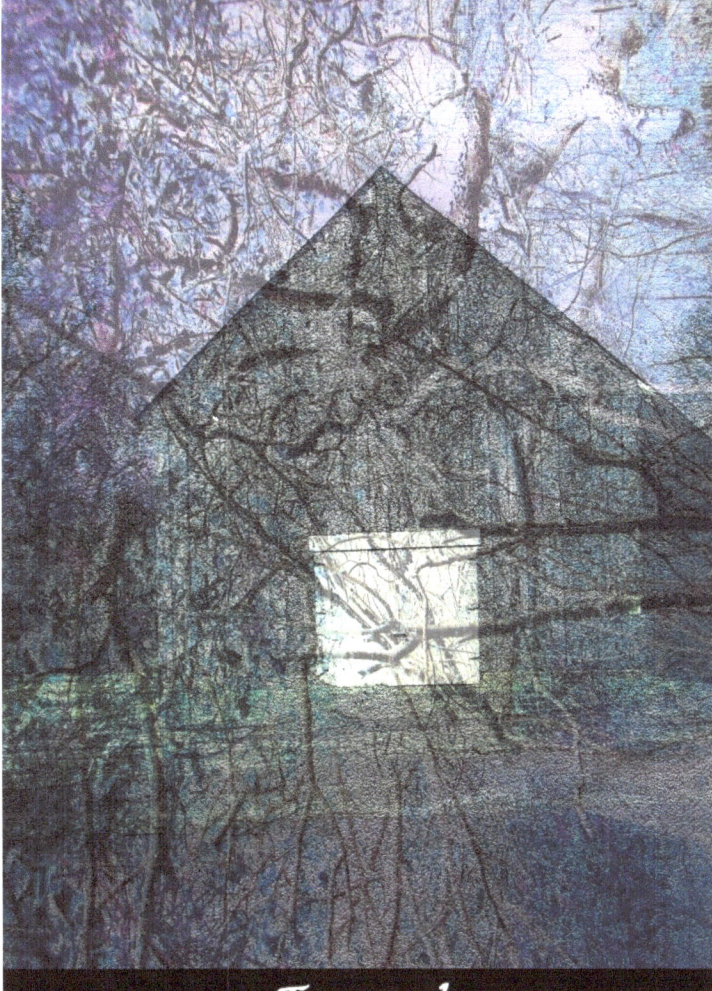

BEHIND BRANCHES

Trapped
Tied and strapped
The past is locked tight
Treasures out of sight
No second glances
At the barn behind the branches

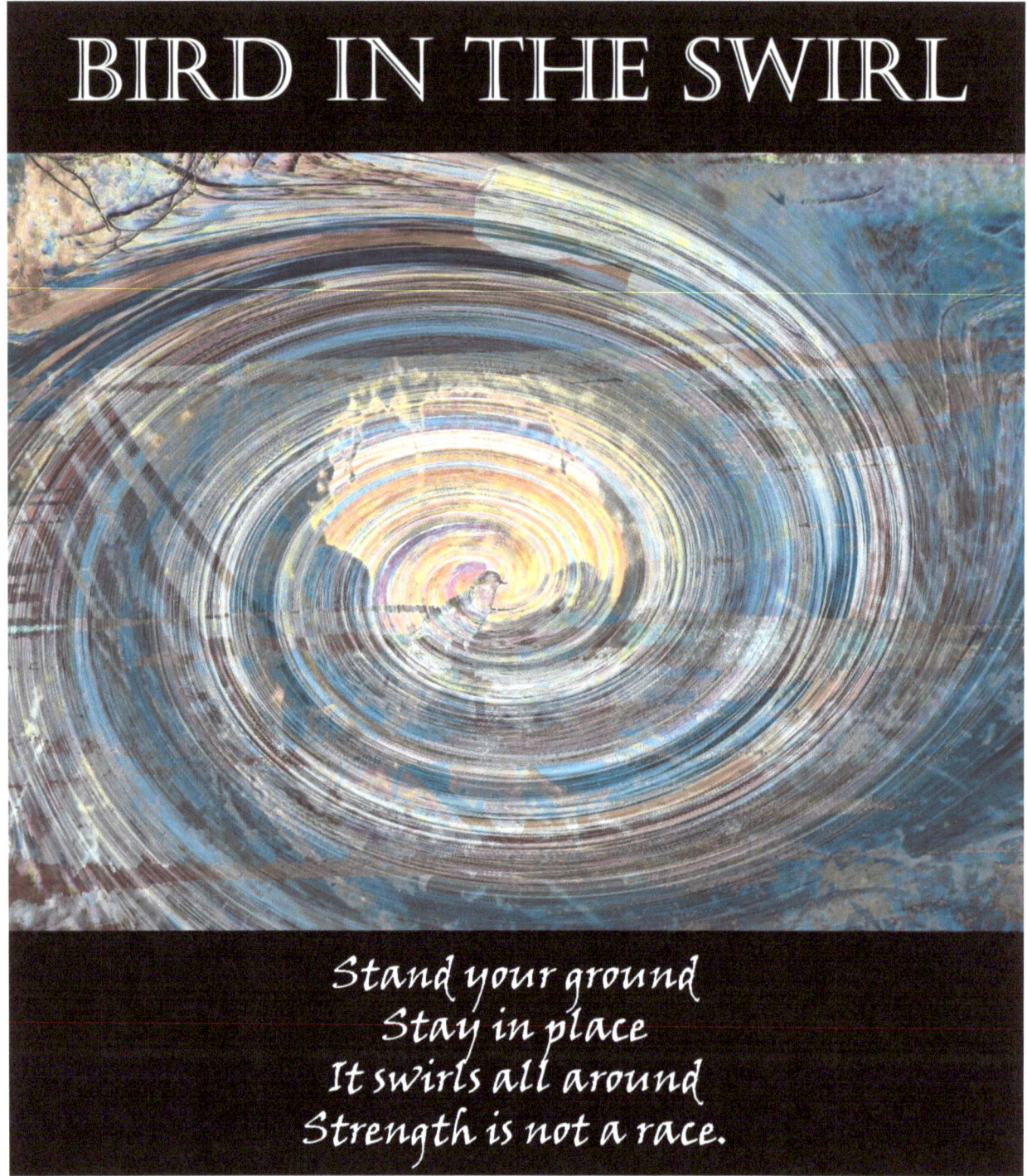

BLOOD SHED

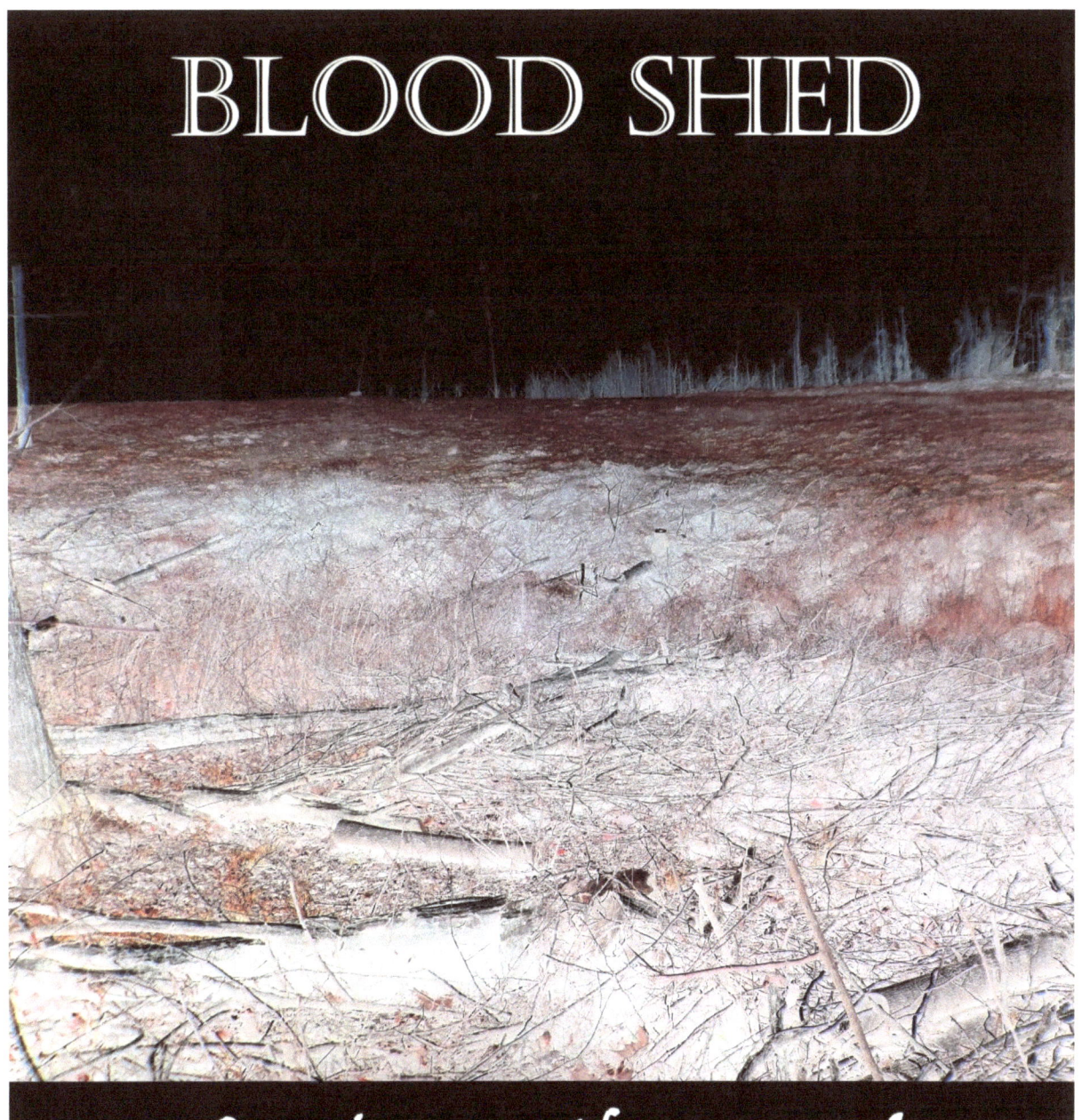

Laying on the ground
Demolished and mutilated
Blood all around
Feeling so isolated.

BLUE LIGHT

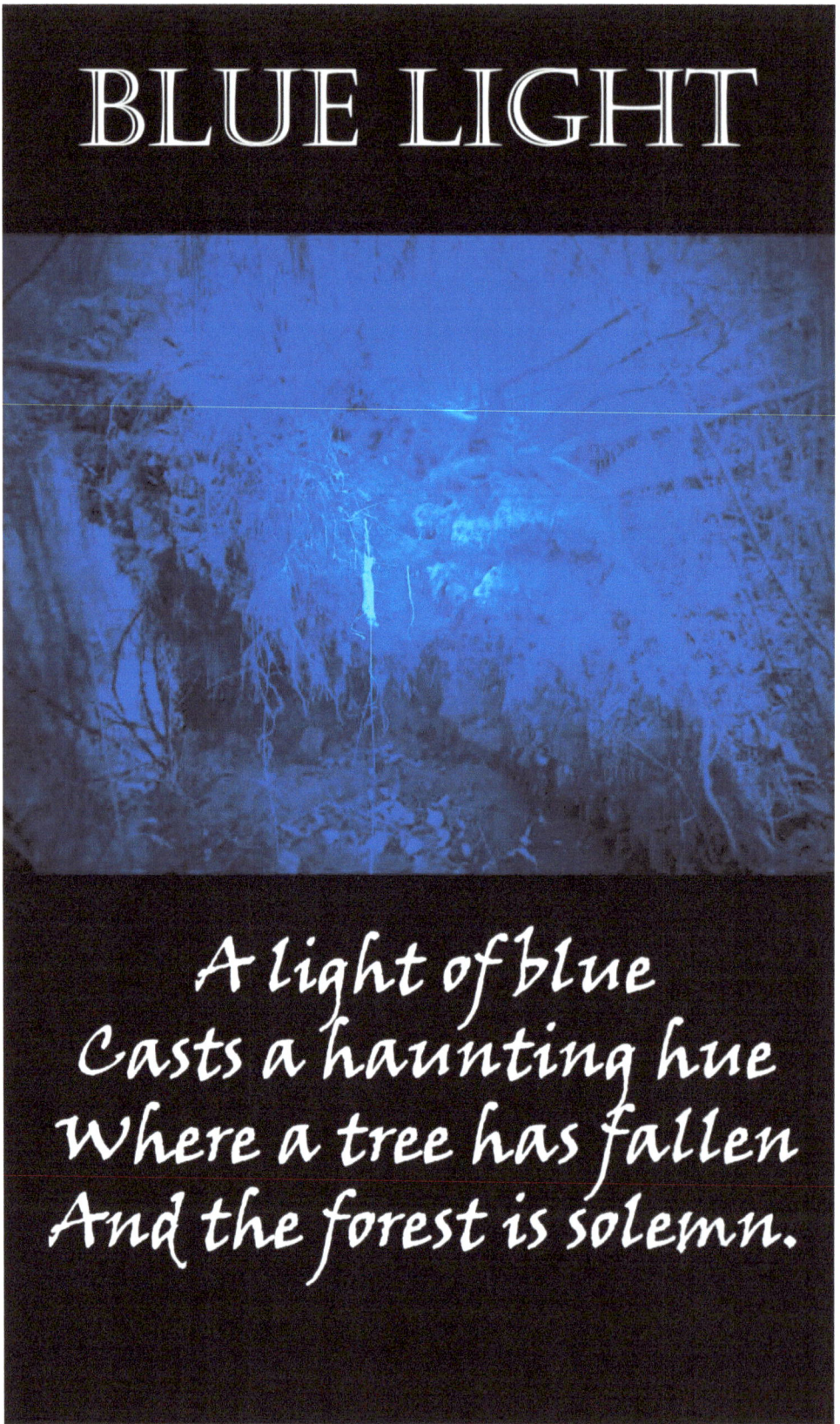

A light of blue
Casts a haunting hue
Where a tree has fallen
And the forest is solemn.

BOUND

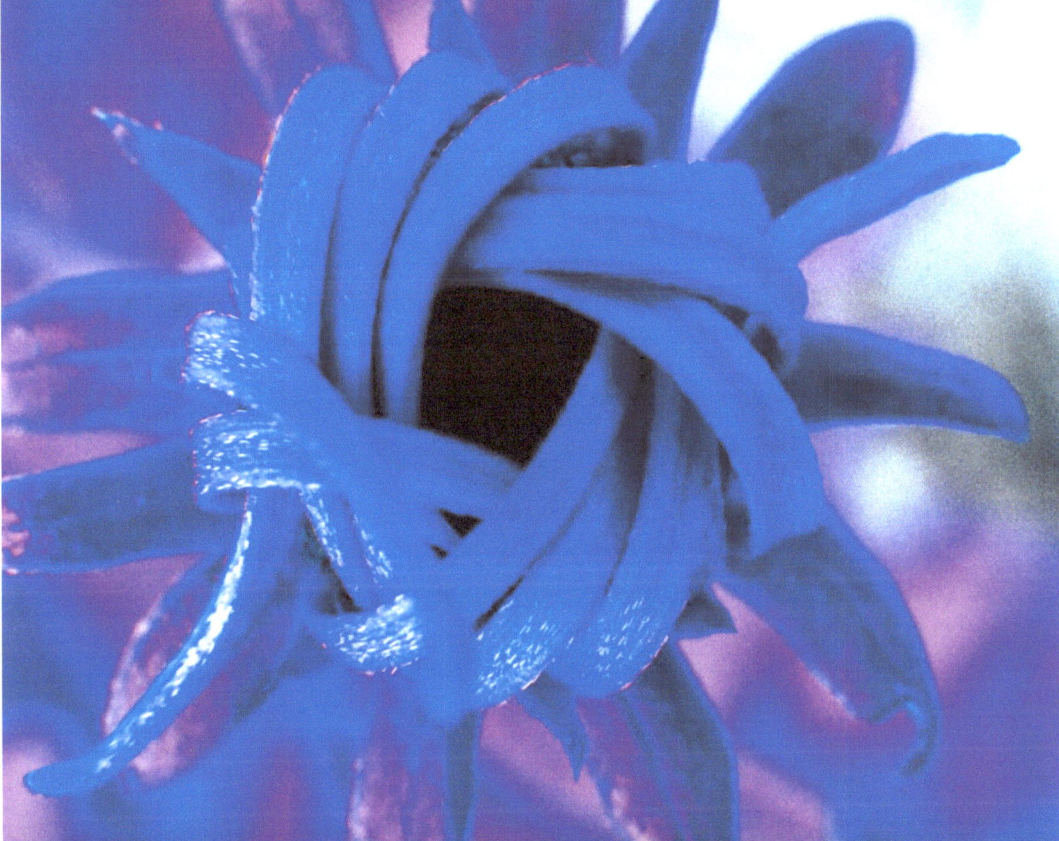

Tied in a knot
I am stuck, I am caught
Feelings entwined
Enchanted, captivated, and blind
In you my sadness drowned
My soul is bound

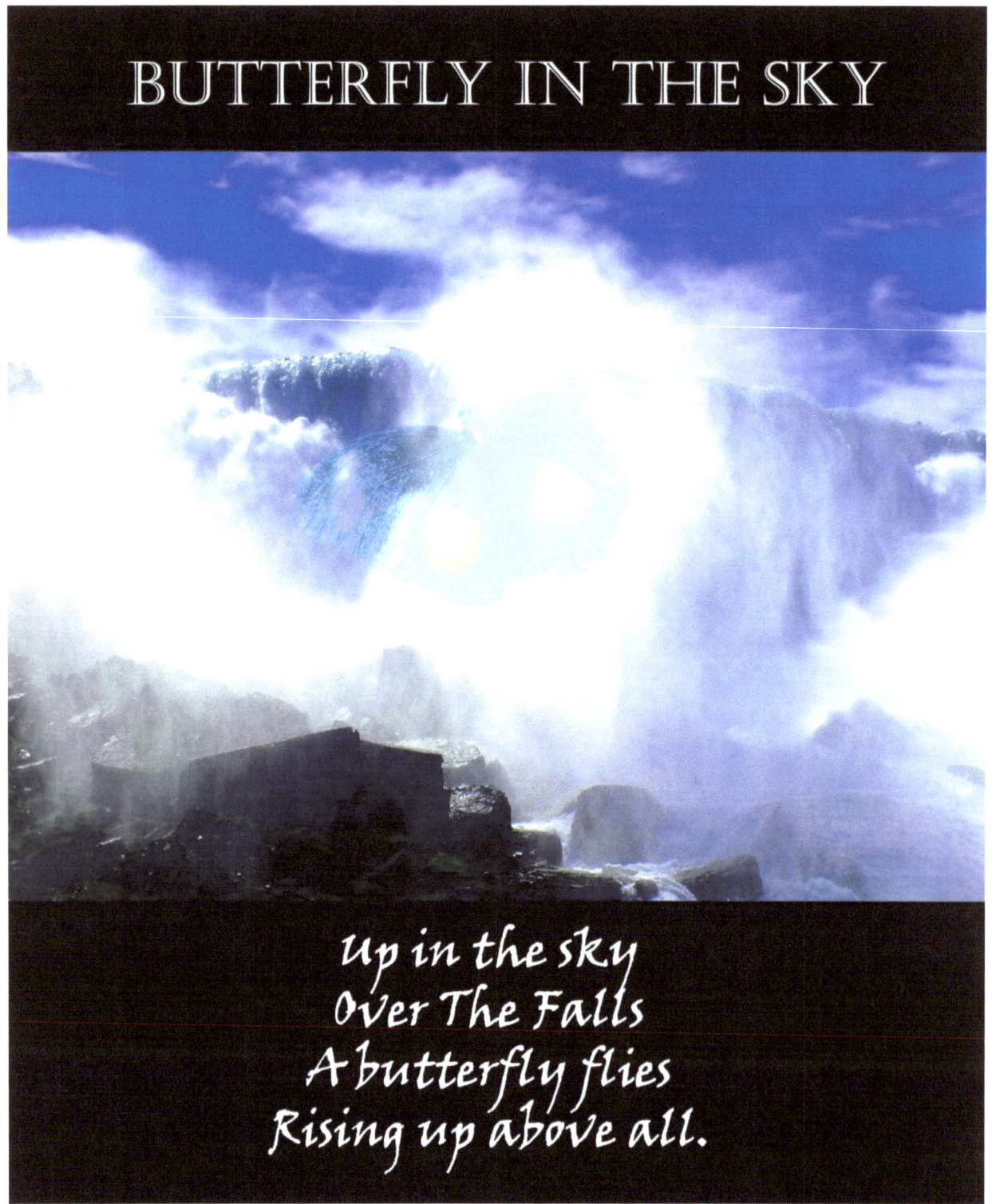

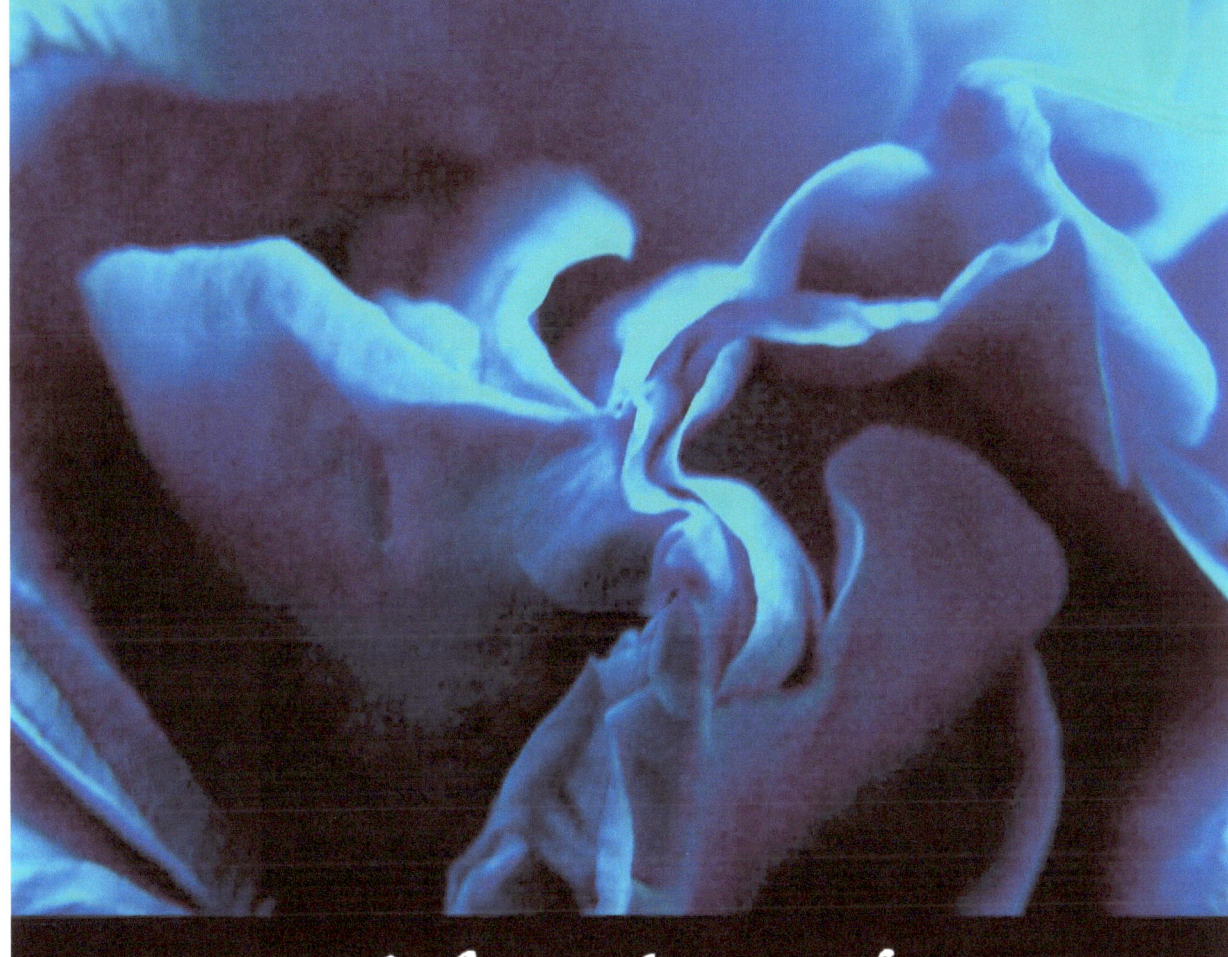

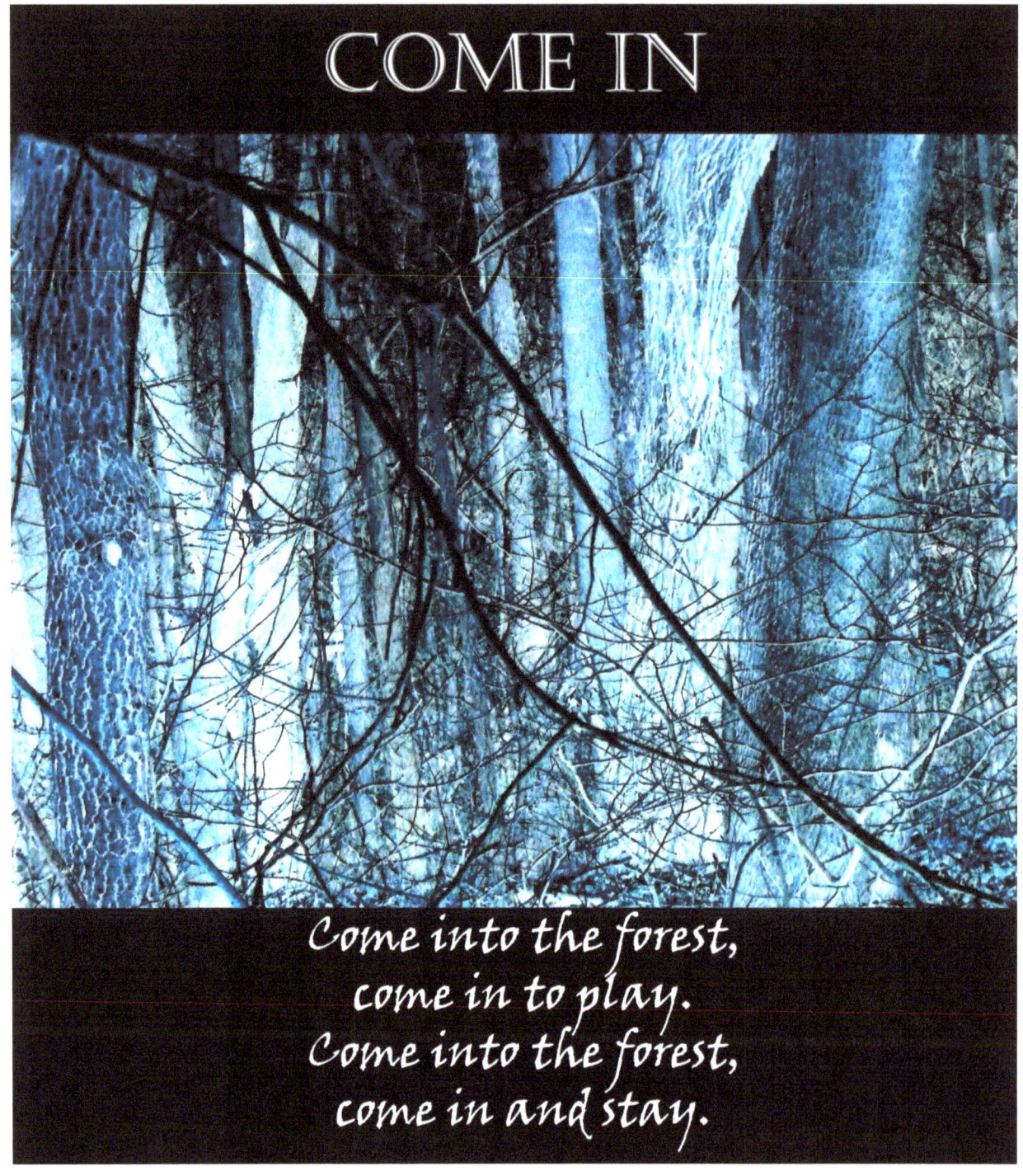

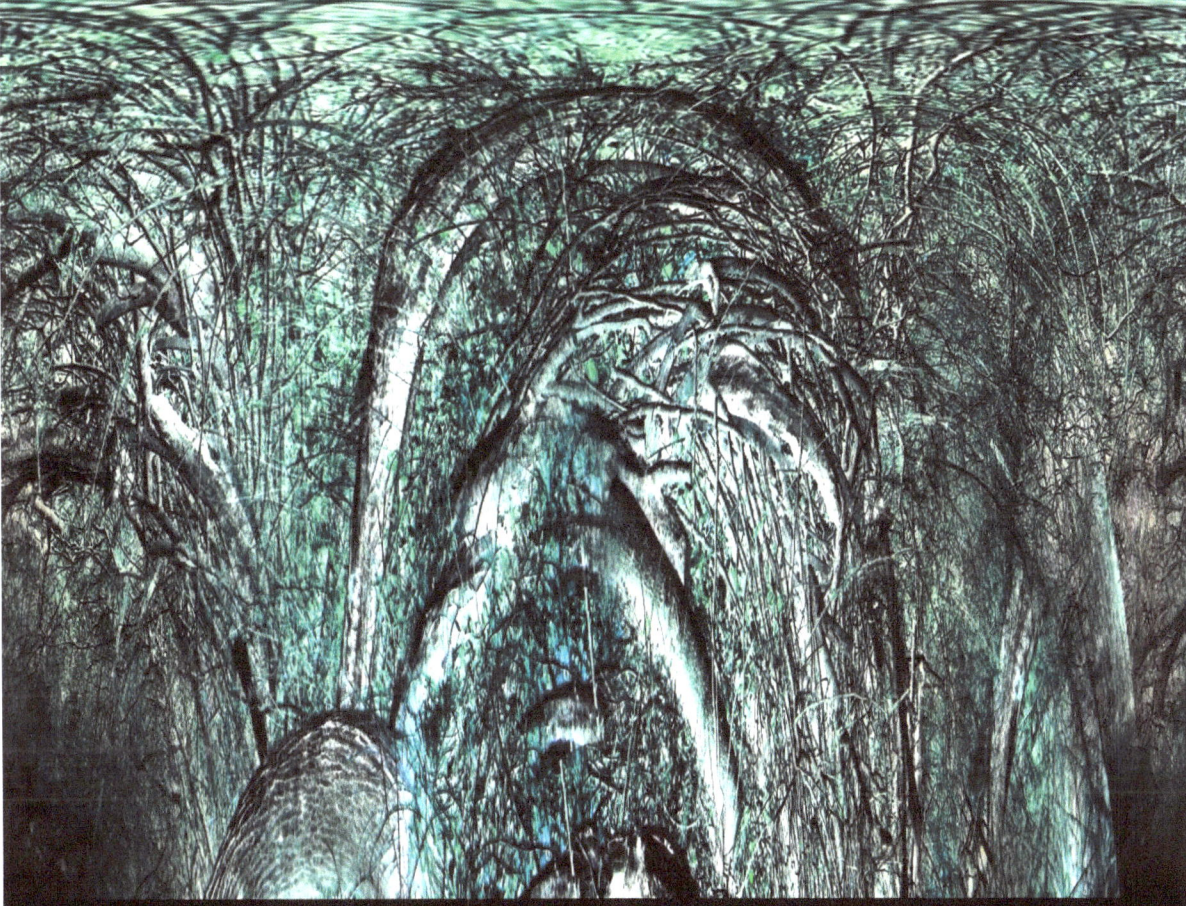

CRAWL

Tender and aching
Always bending, never breaking
A world of pain
With happiness to regain.

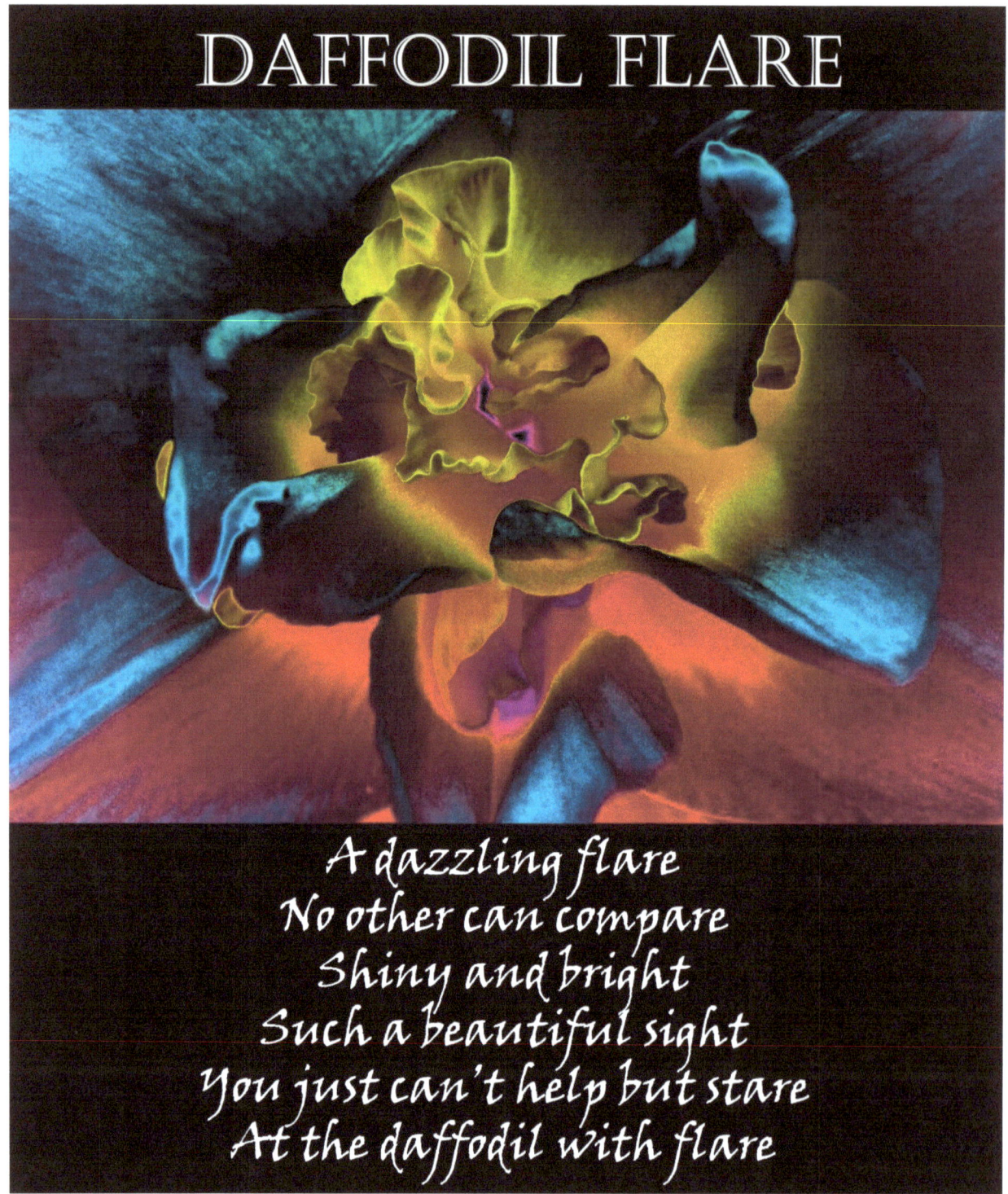

DARK FLOWERS

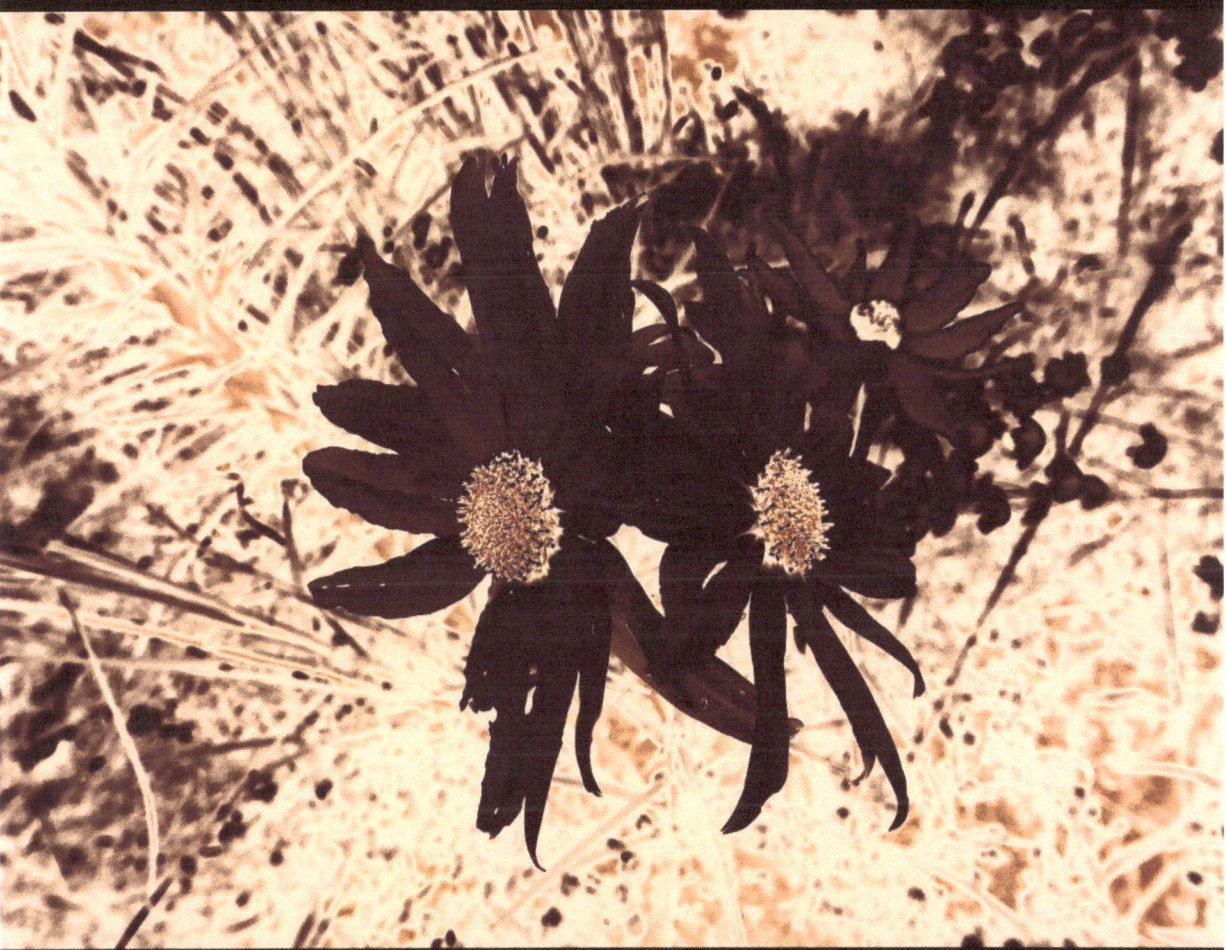

Dark flowers in the sun
Reaching out, having fun
Petals long and sleek
Enjoyment they do seek.

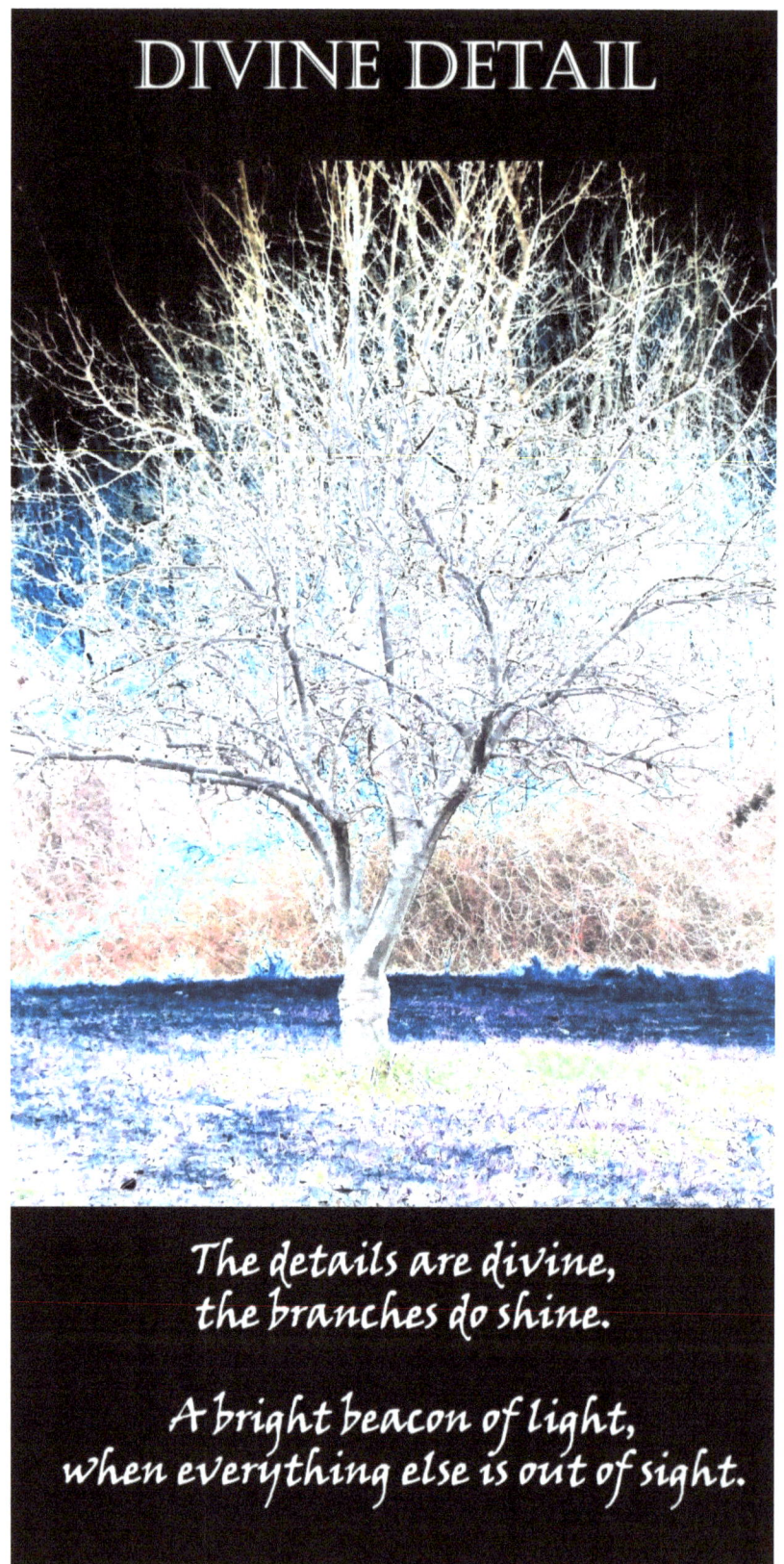

DUCKS IN A DREAM

Ducks in a dream
Clouds in the sea
Under the soft moonbeam
There is rest for me.

ELECTRIC

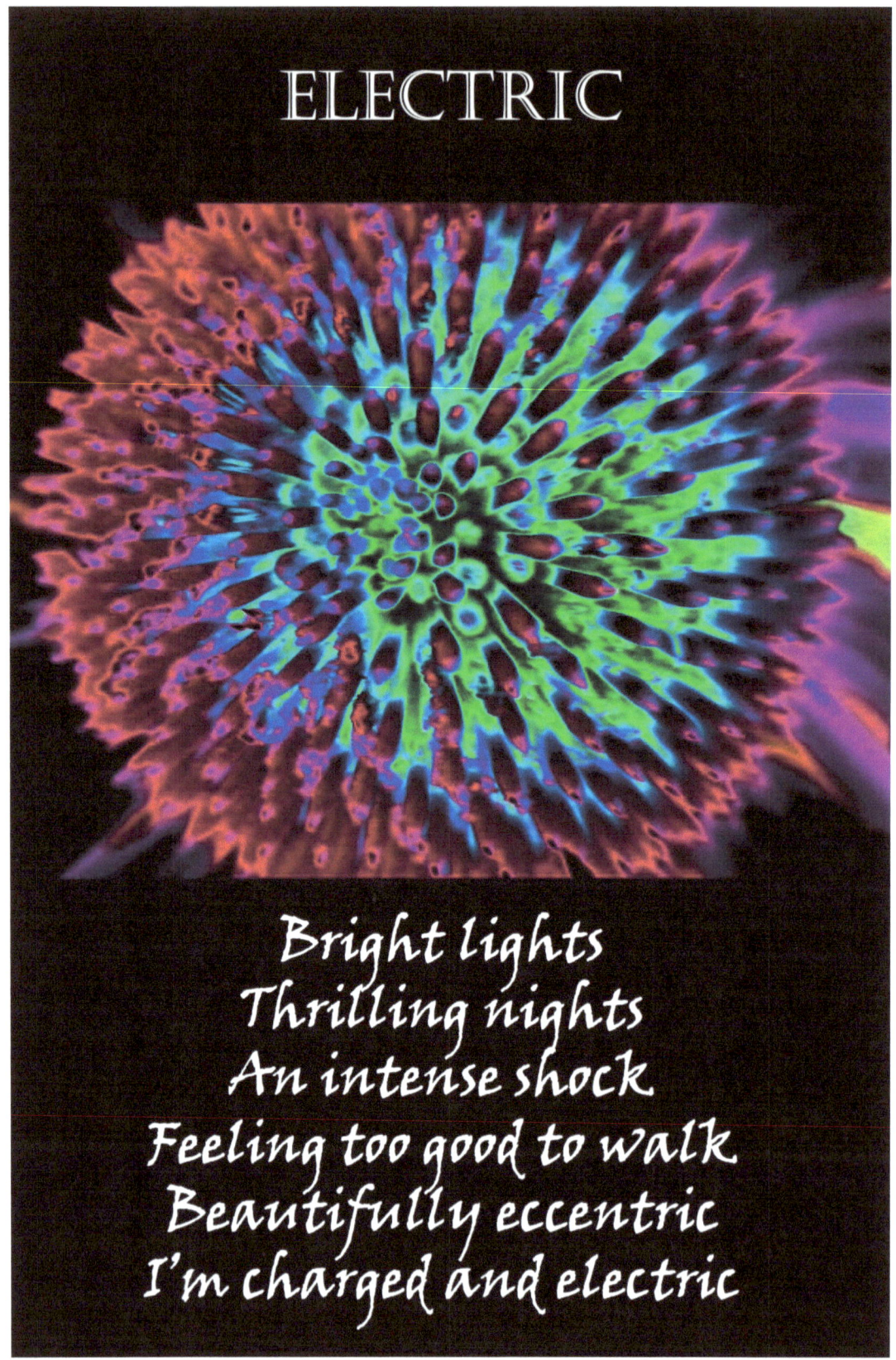

Bright lights
Thrilling nights
An intense shock
Feeling too good to walk
Beautifully eccentric
I'm charged and electric

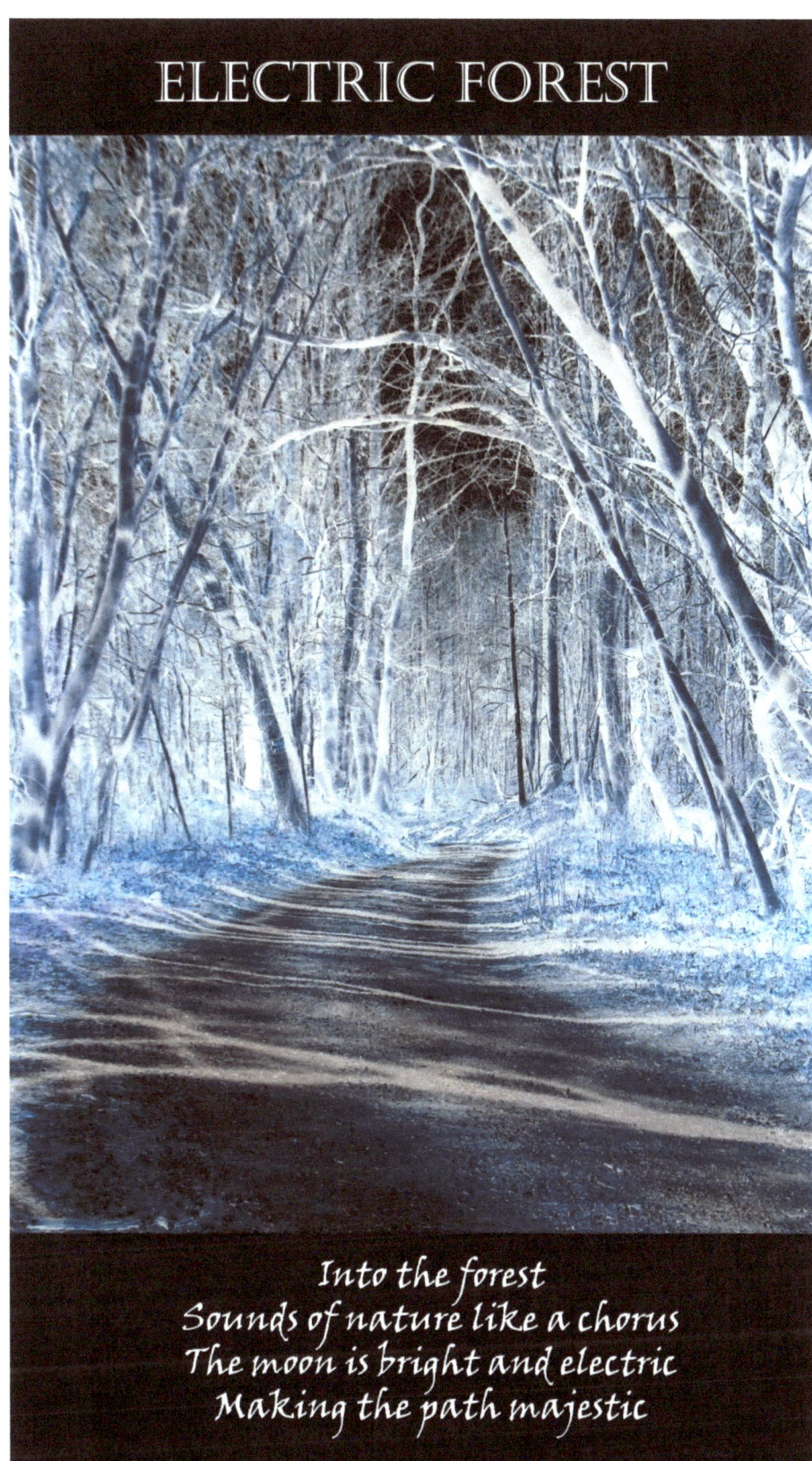

ELECTRIC FOREST

Into the forest
Sounds of nature like a chorus
The moon is bright and electric
Making the path majestic

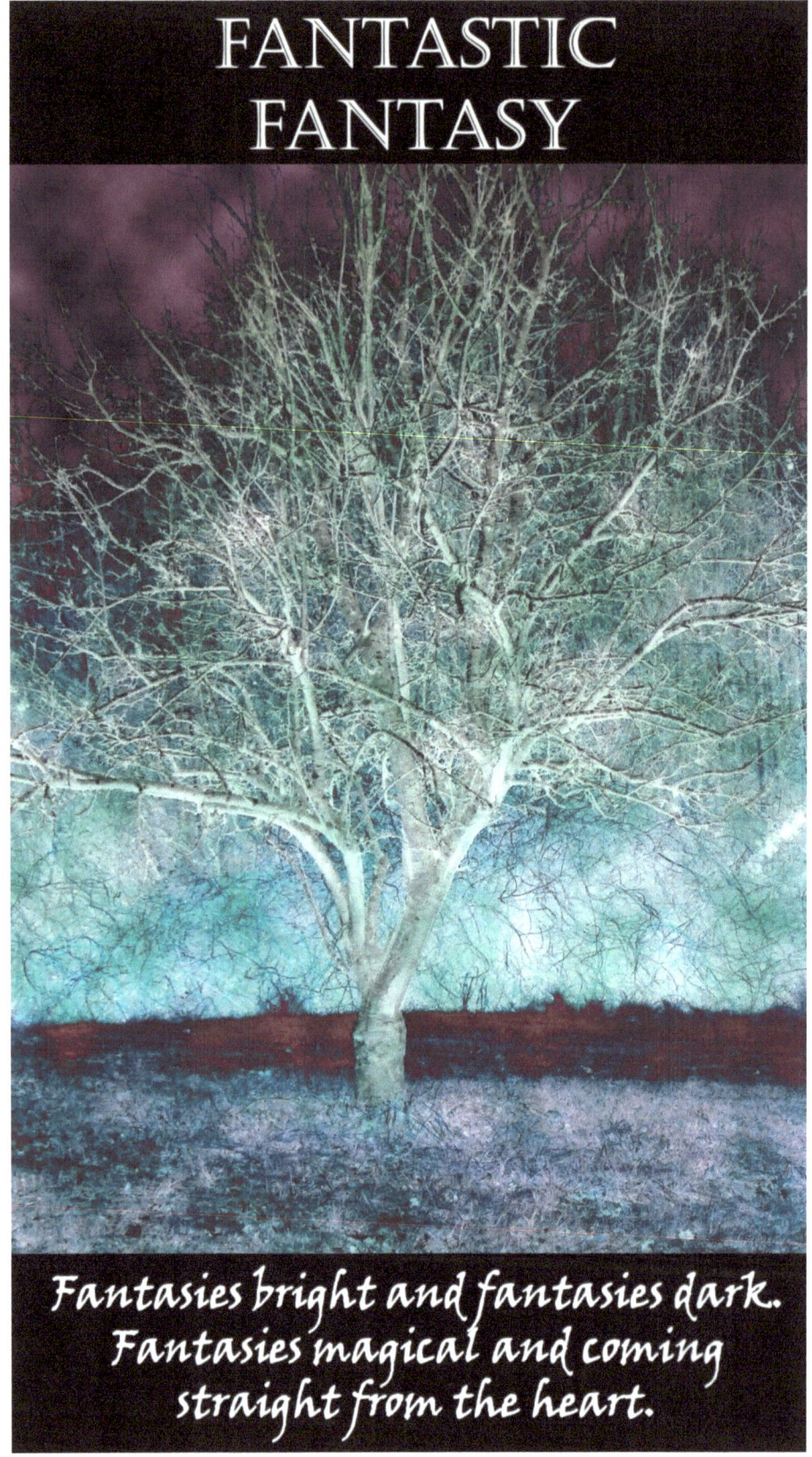

FANTASY FLOWERS

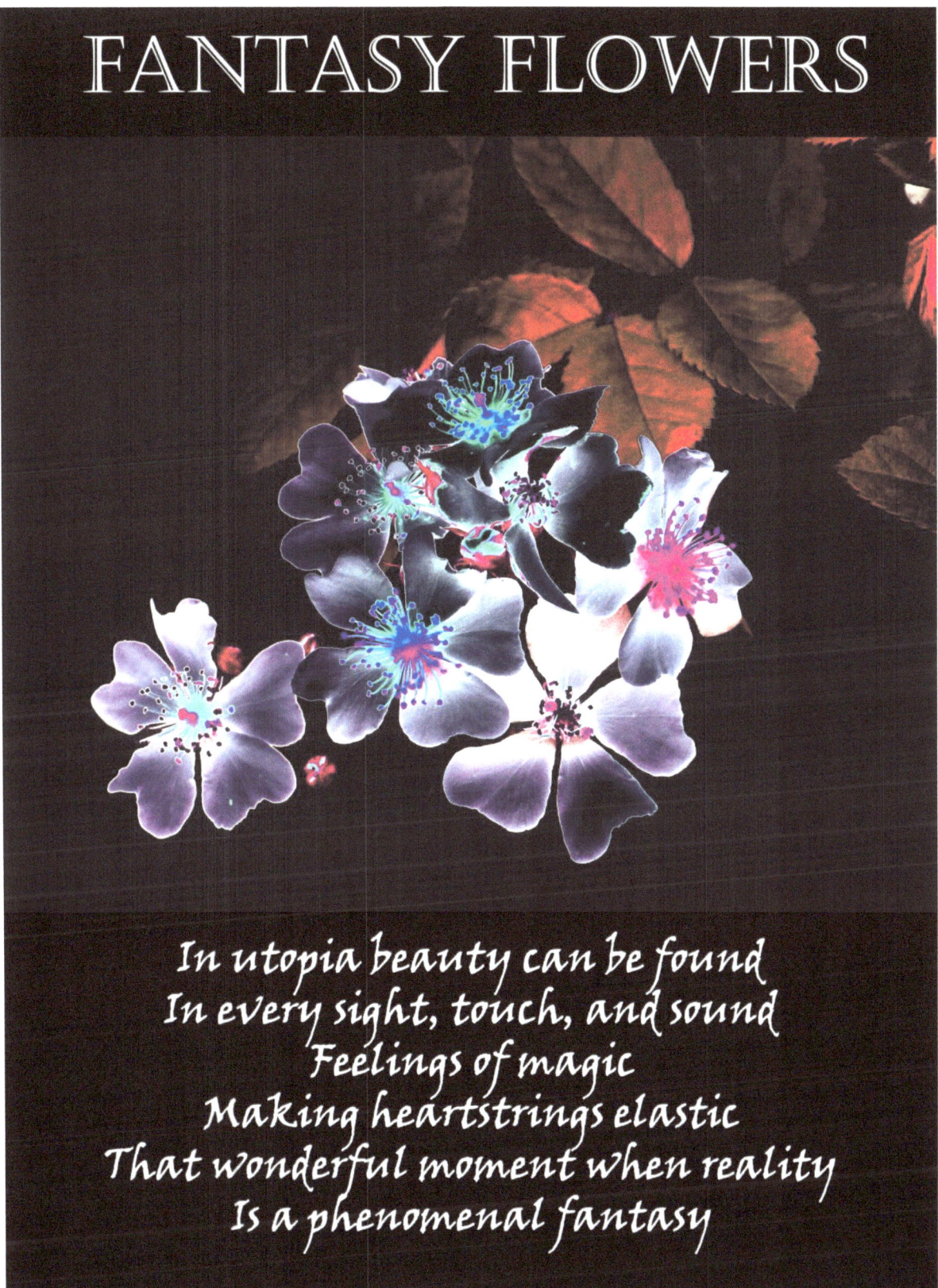

In utopia beauty can be found
In every sight, touch, and sound
Feelings of magic
Making heartstrings elastic
That wonderful moment when reality
Is a phenomenal fantasy

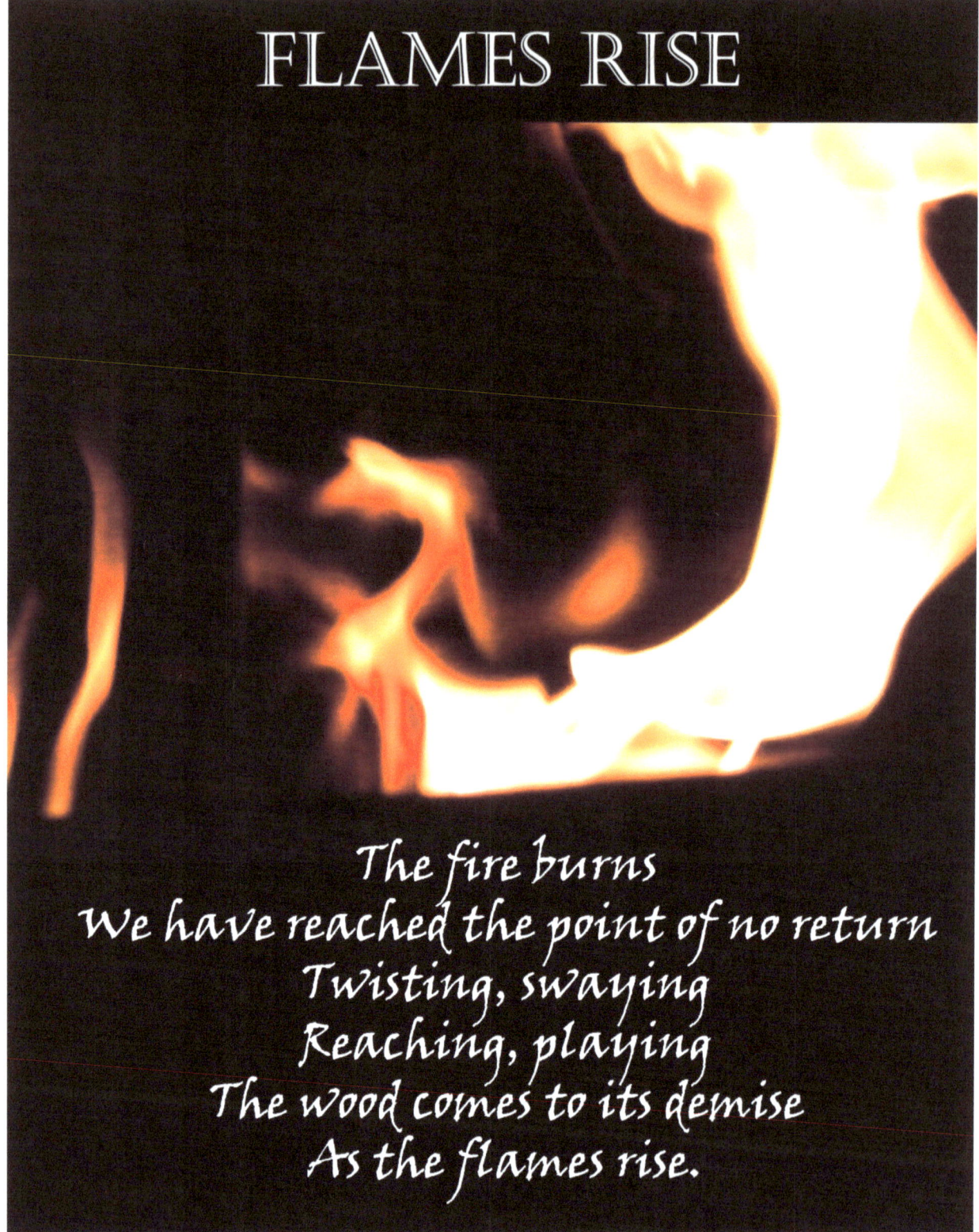

FLAMES RISE

The fire burns
We have reached the point of no return
Twisting, swaying
Reaching, playing
The wood comes to its demise
As the flames rise.

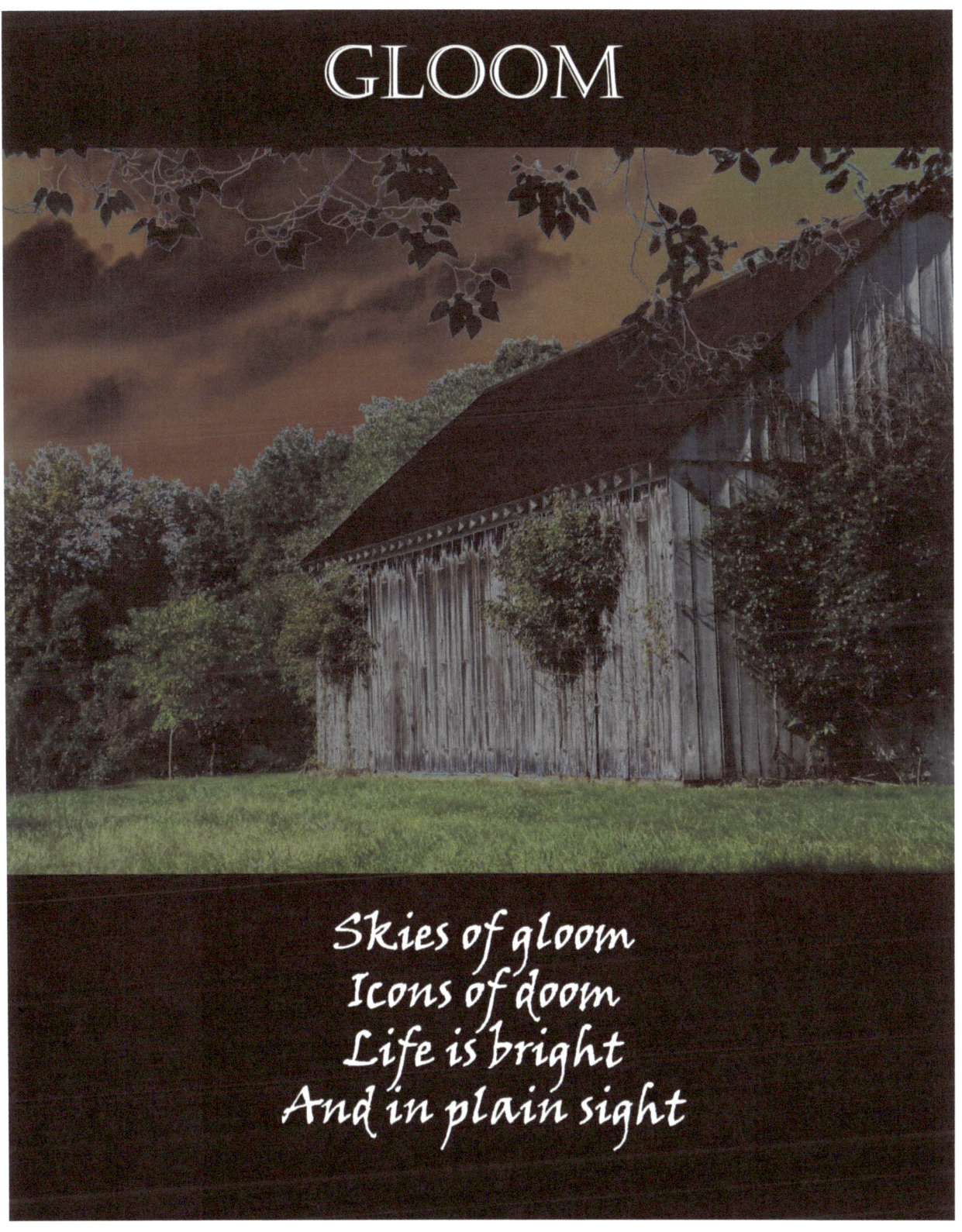

GROWTH

In the darkness
In the rain
The light will find us
And take away our pain.

KNOTTED

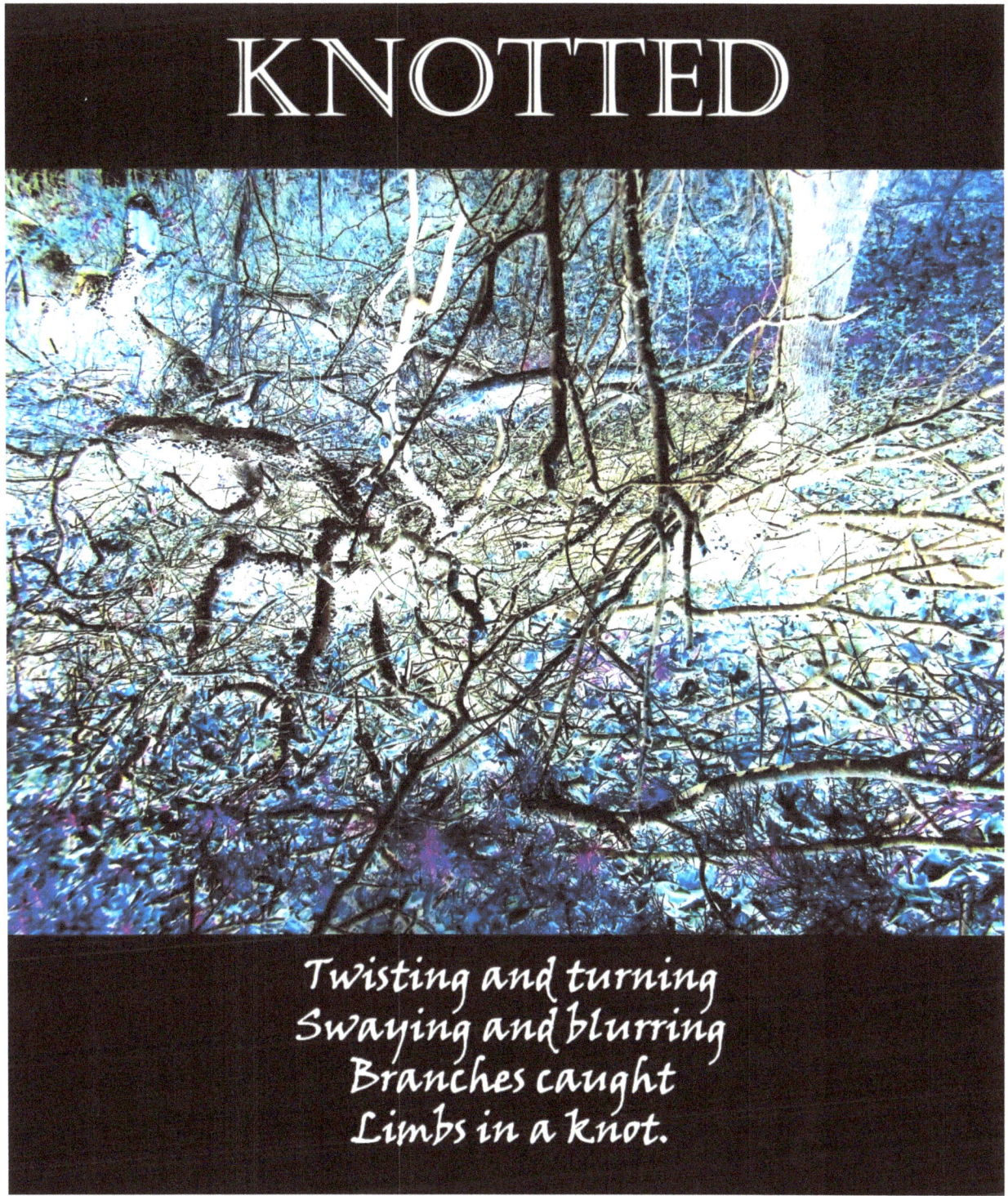

Twisting and turning
Swaying and blurring
Branches caught
Limbs in a knot.

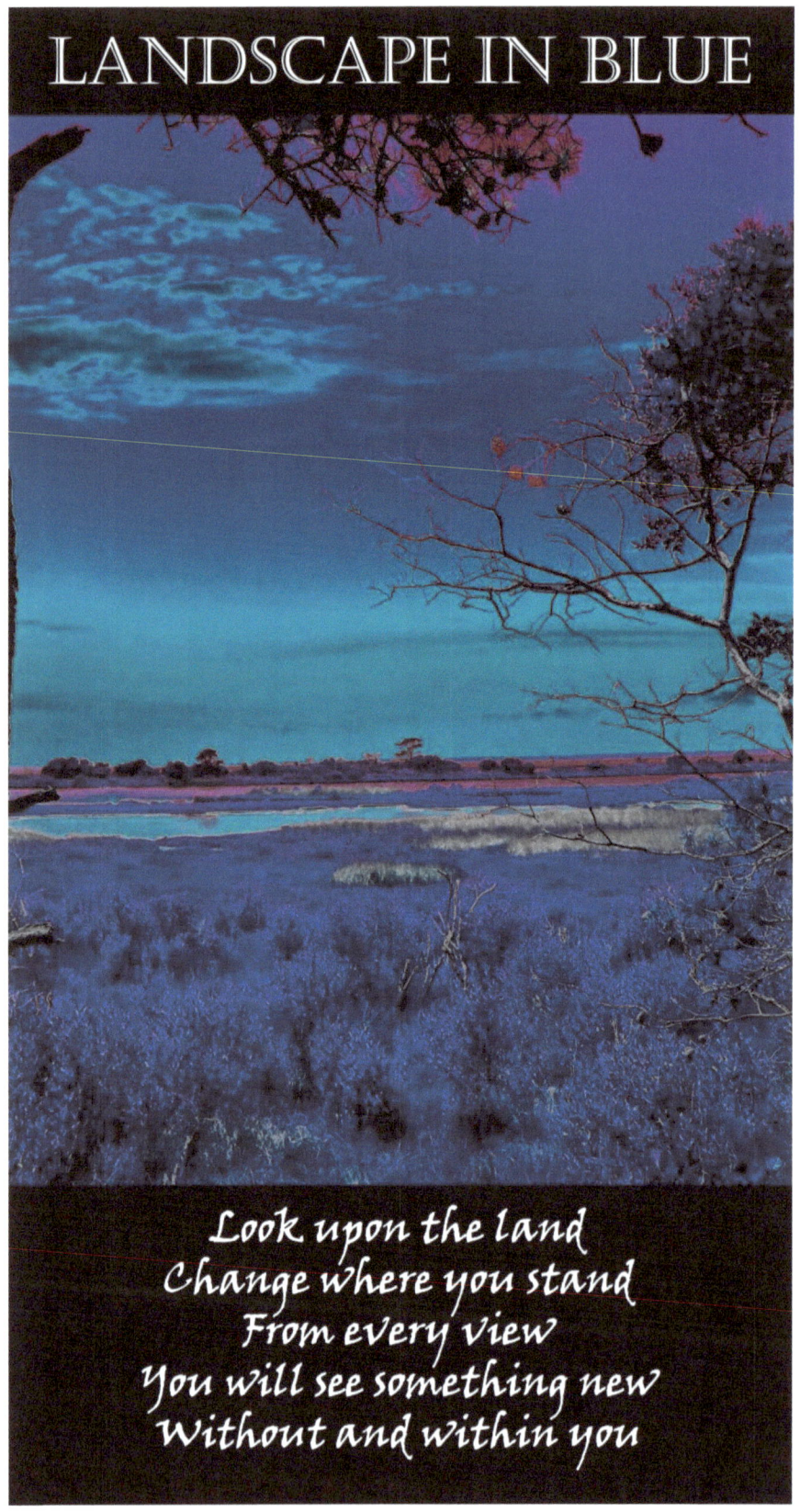

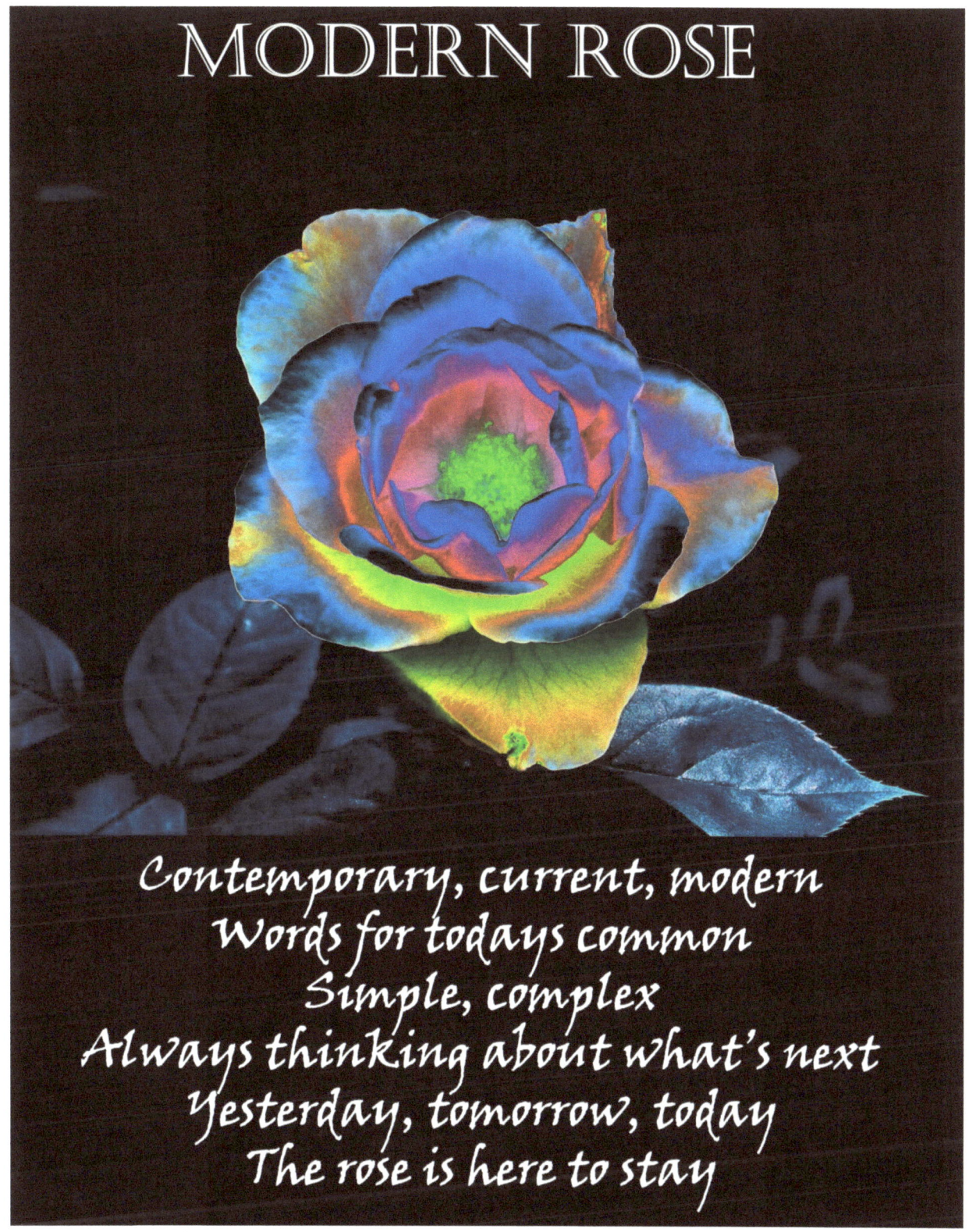

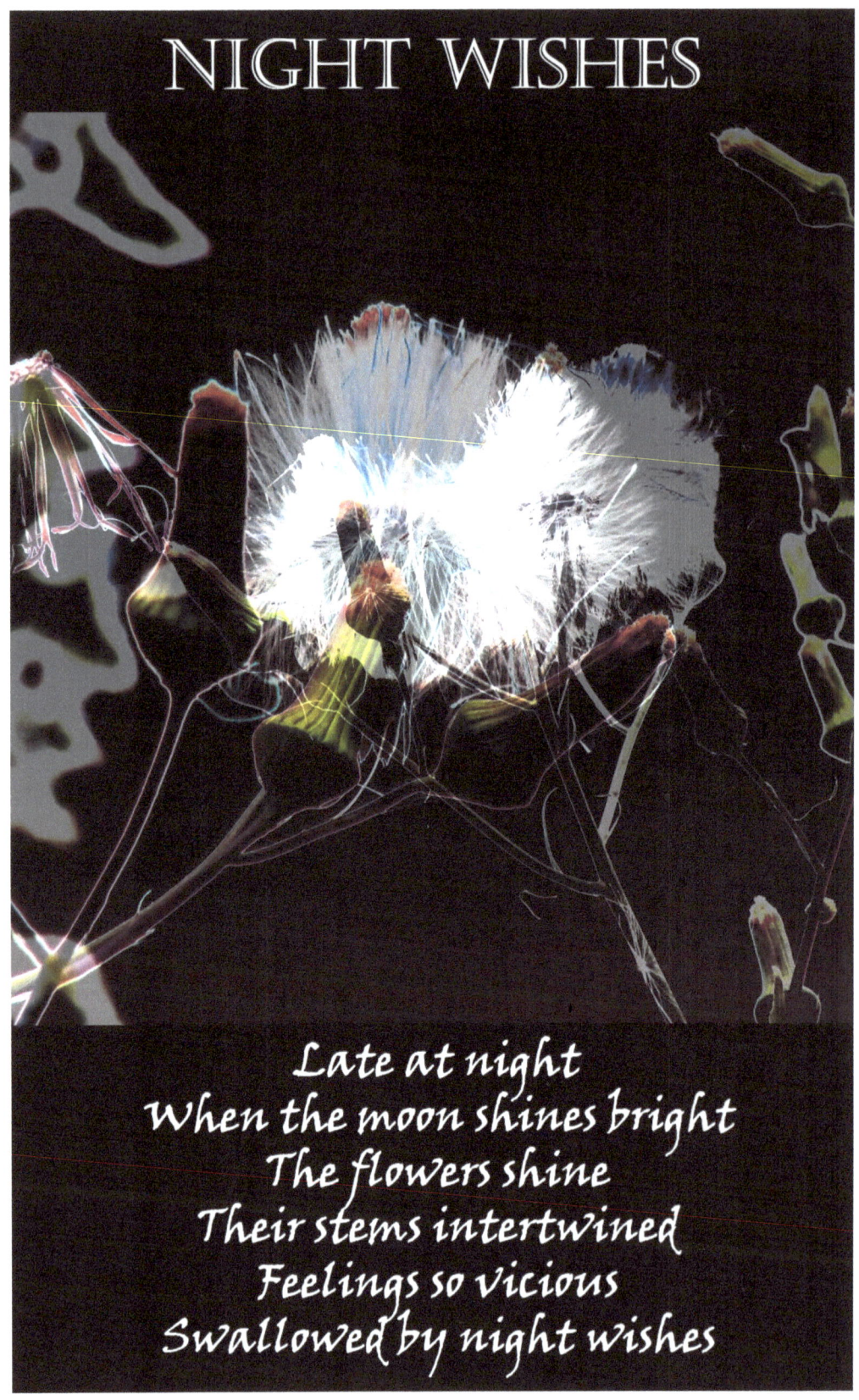

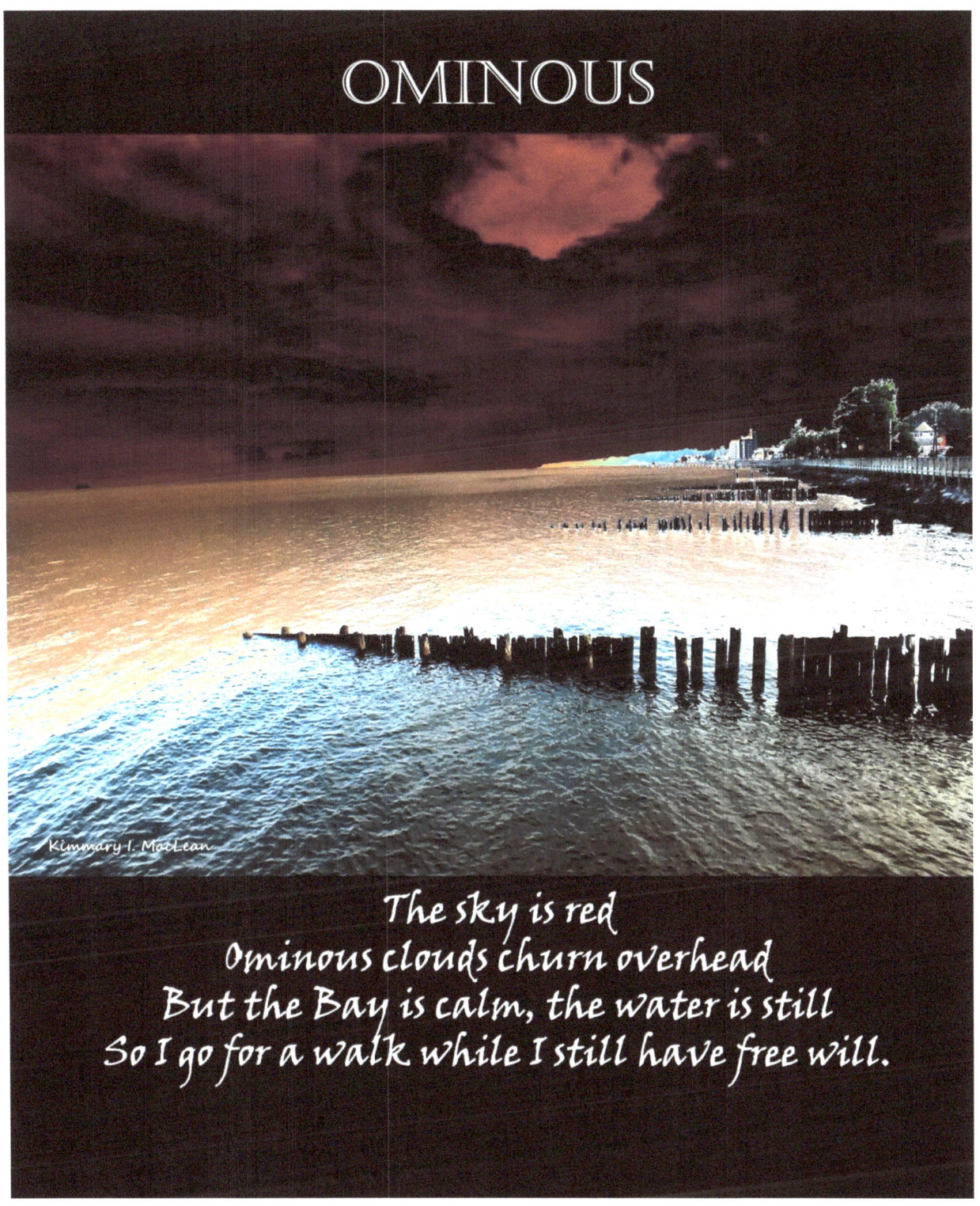

OMINOUS

The sky is red
Ominous clouds churn overhead
But the Bay is calm, the water is still
So I go for a walk while I still have free will.

ORGANIC

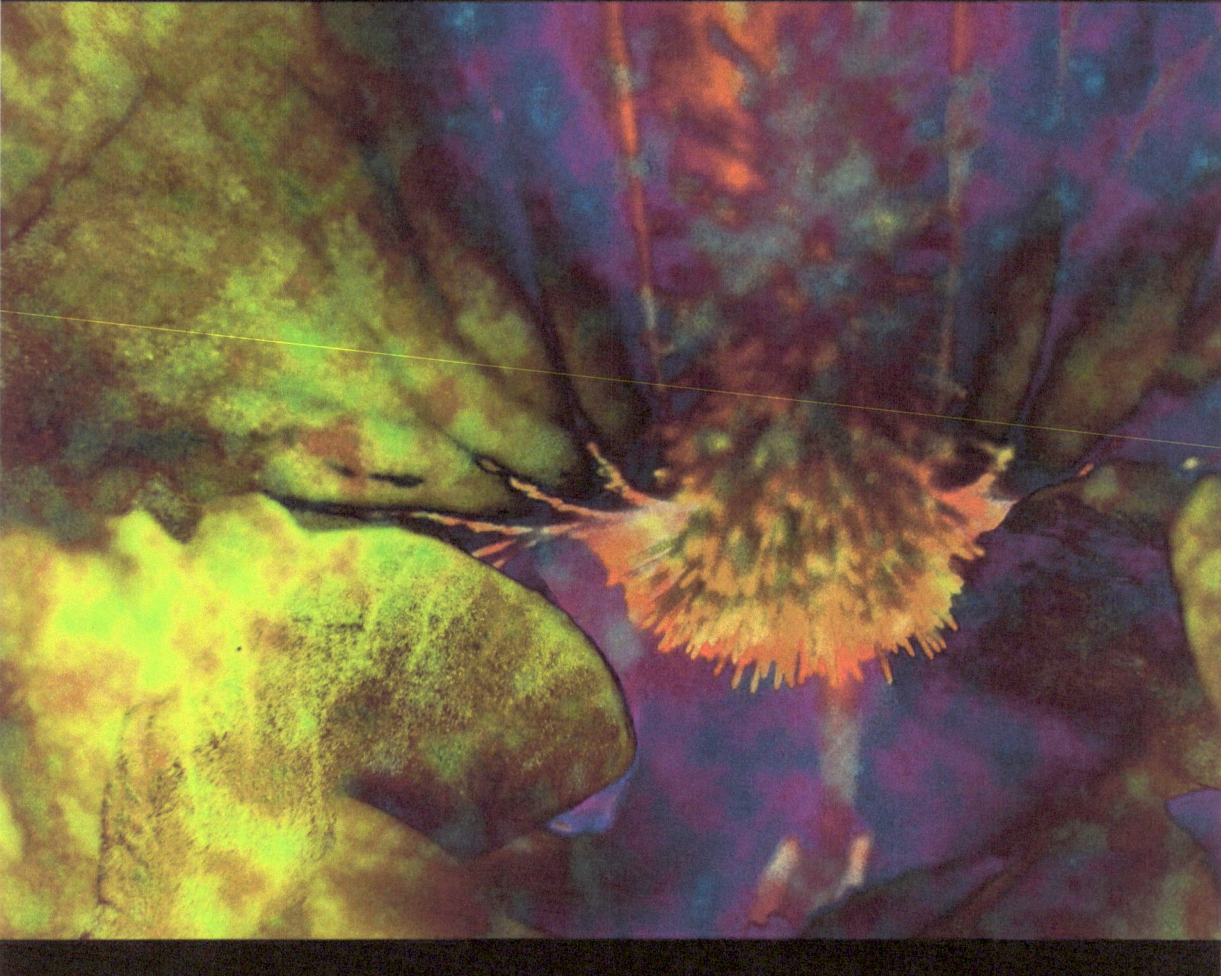

Adorned in feeling
No reason for concealing
A primitive allure
By an organic fleur

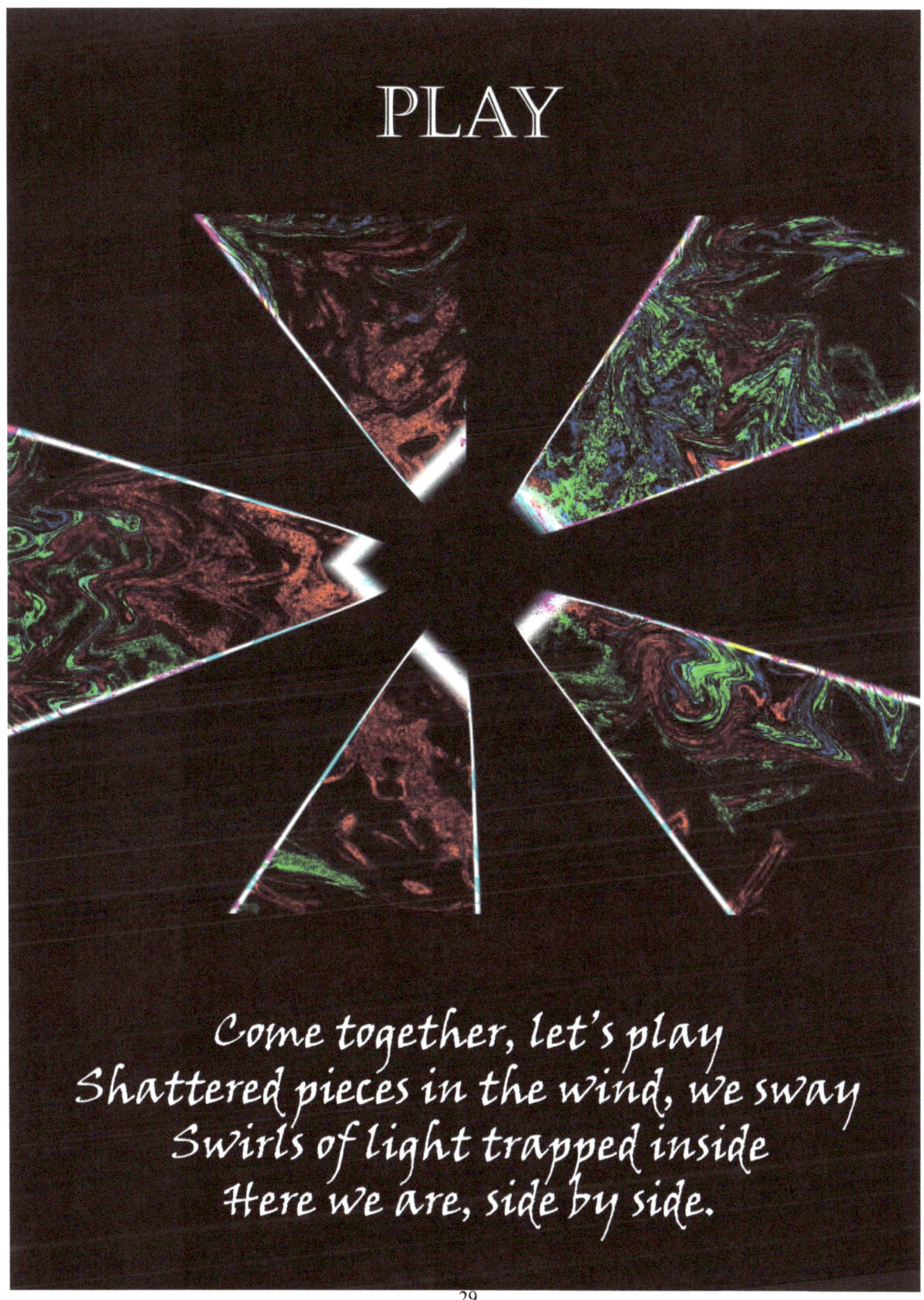

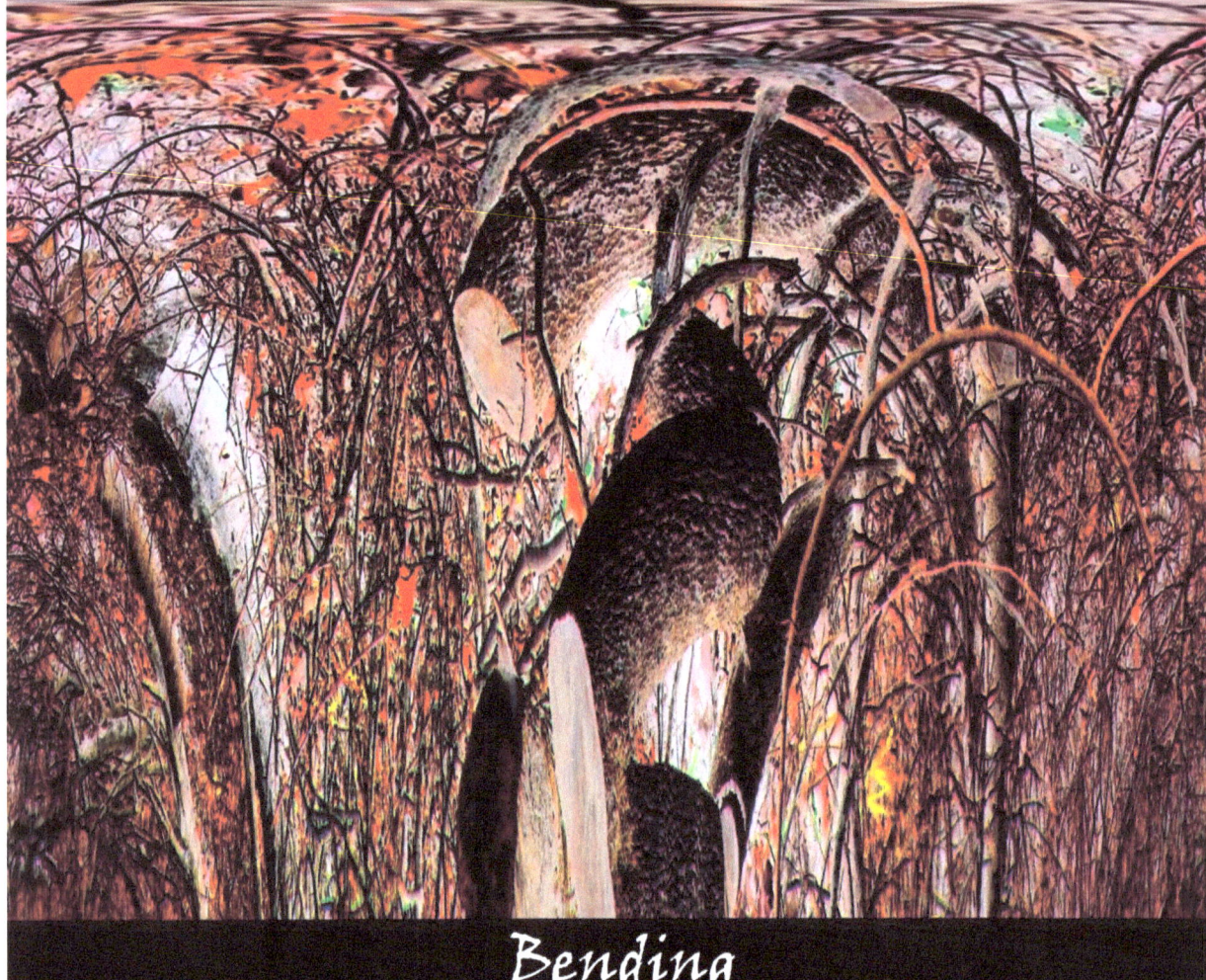

POSTURE

Bending
Posture
Unending
Capture

PURPLE PLACE

Standing tall
Naked in space
The tree's do call
In this purple place.

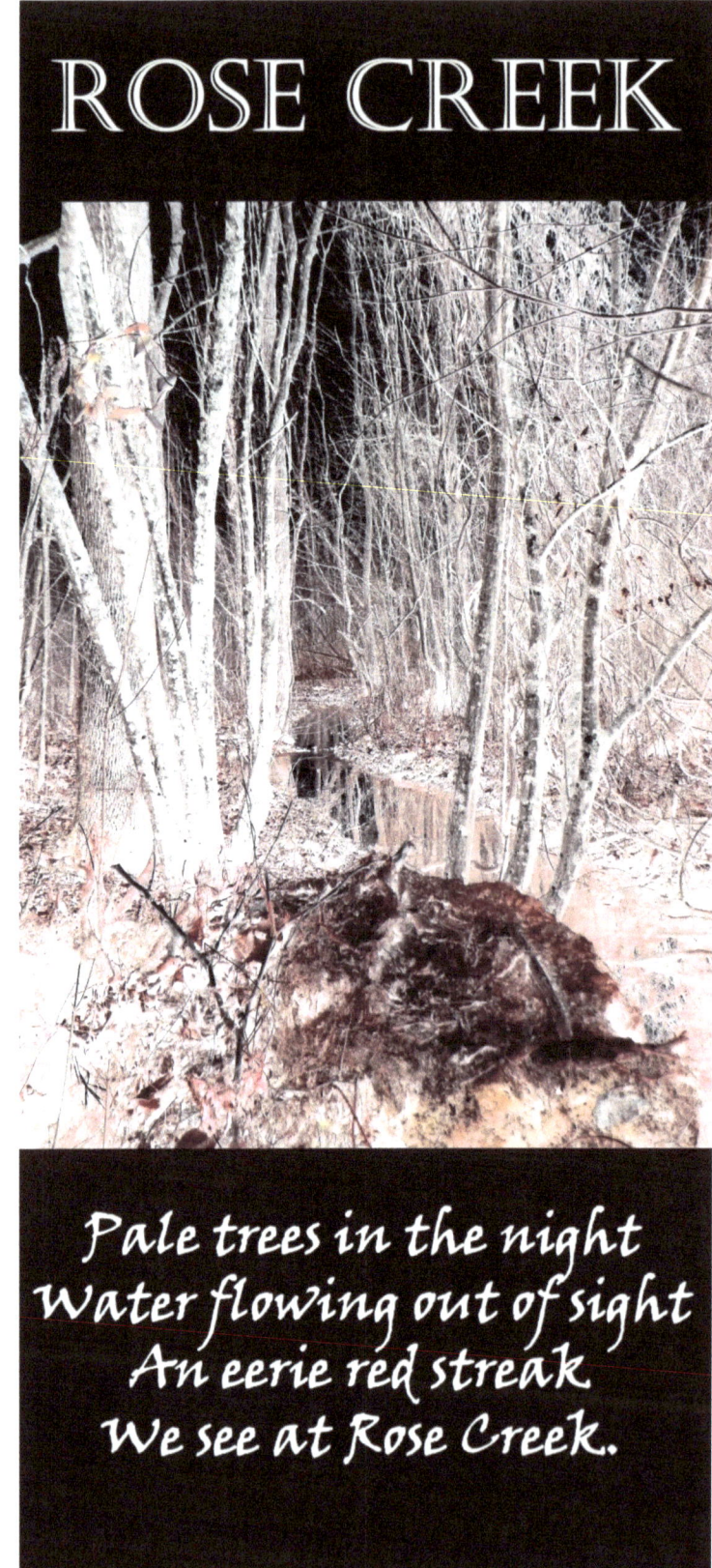

SHINING IN THE DARK

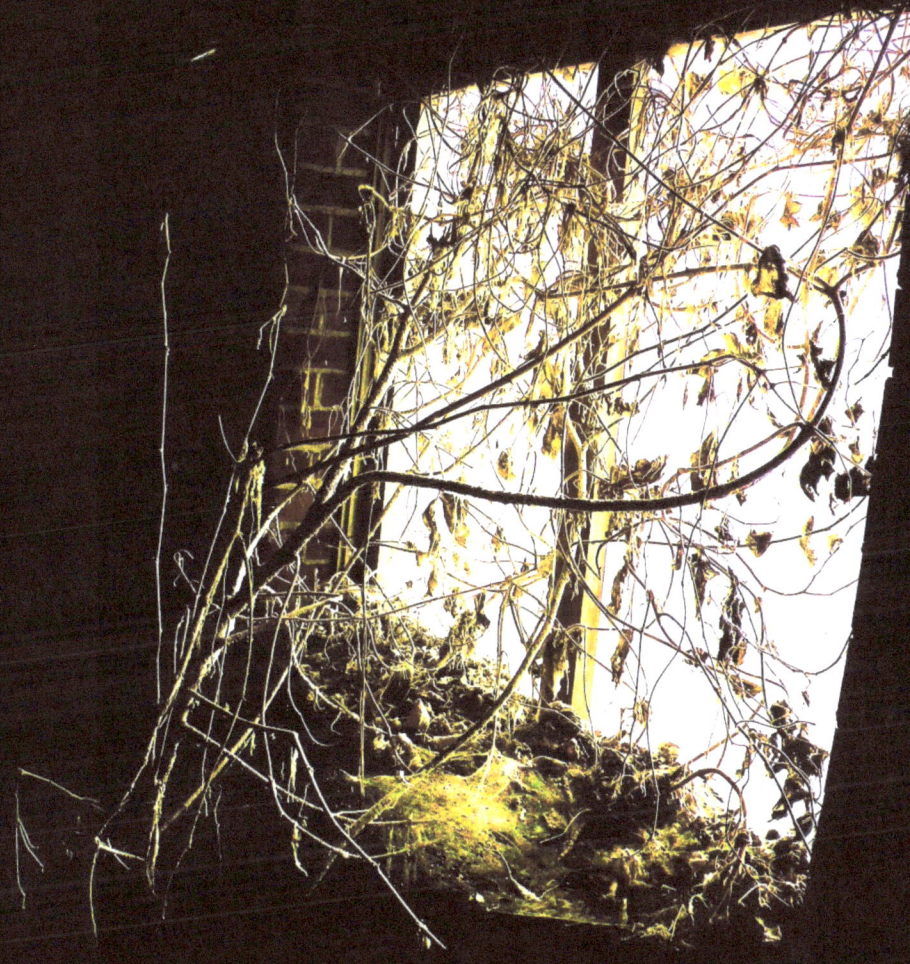

In the dark the vines shine
Behind brick walls they are enshrined
Sheltered and protected
Never collected or disconnected.

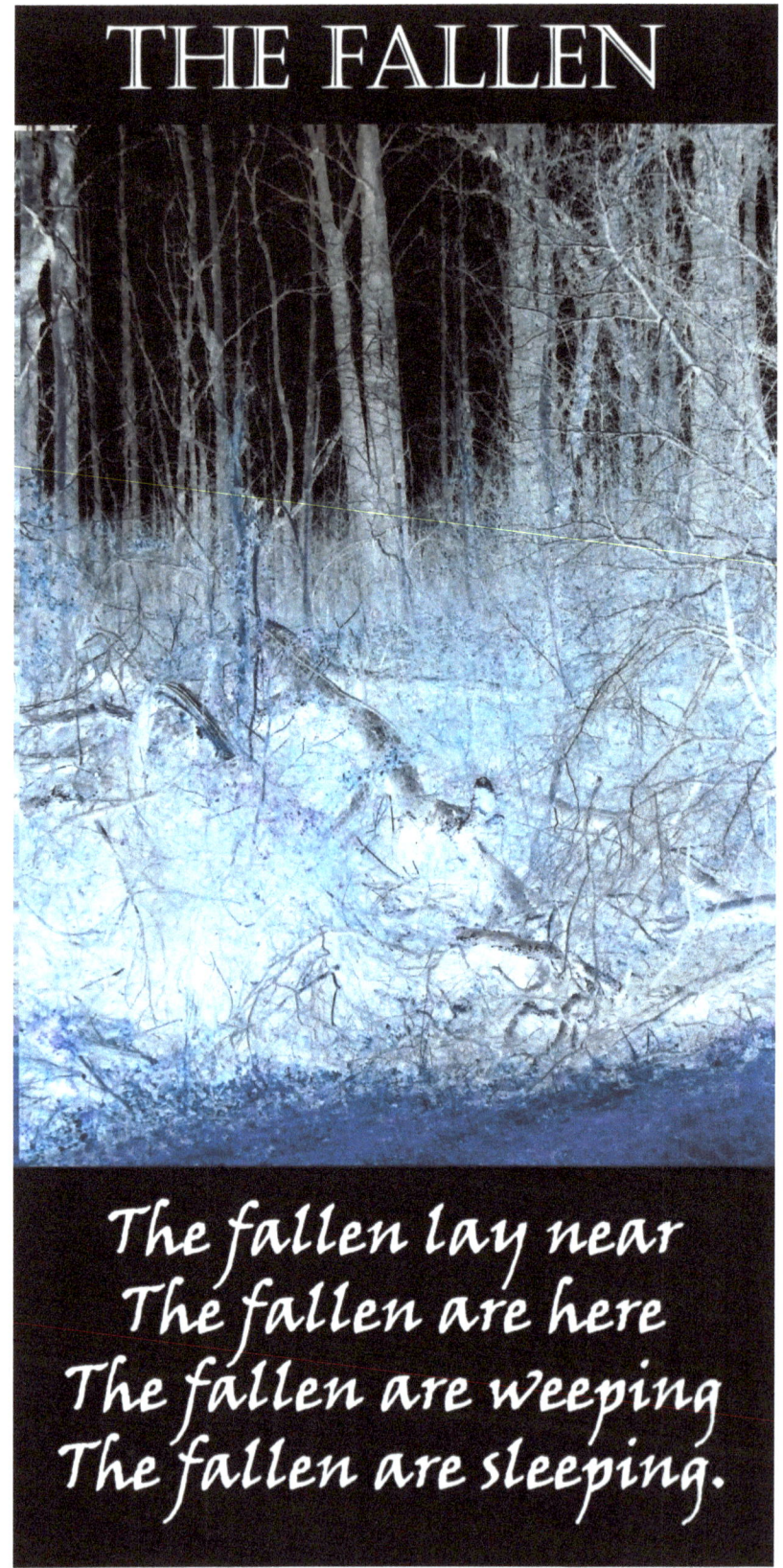

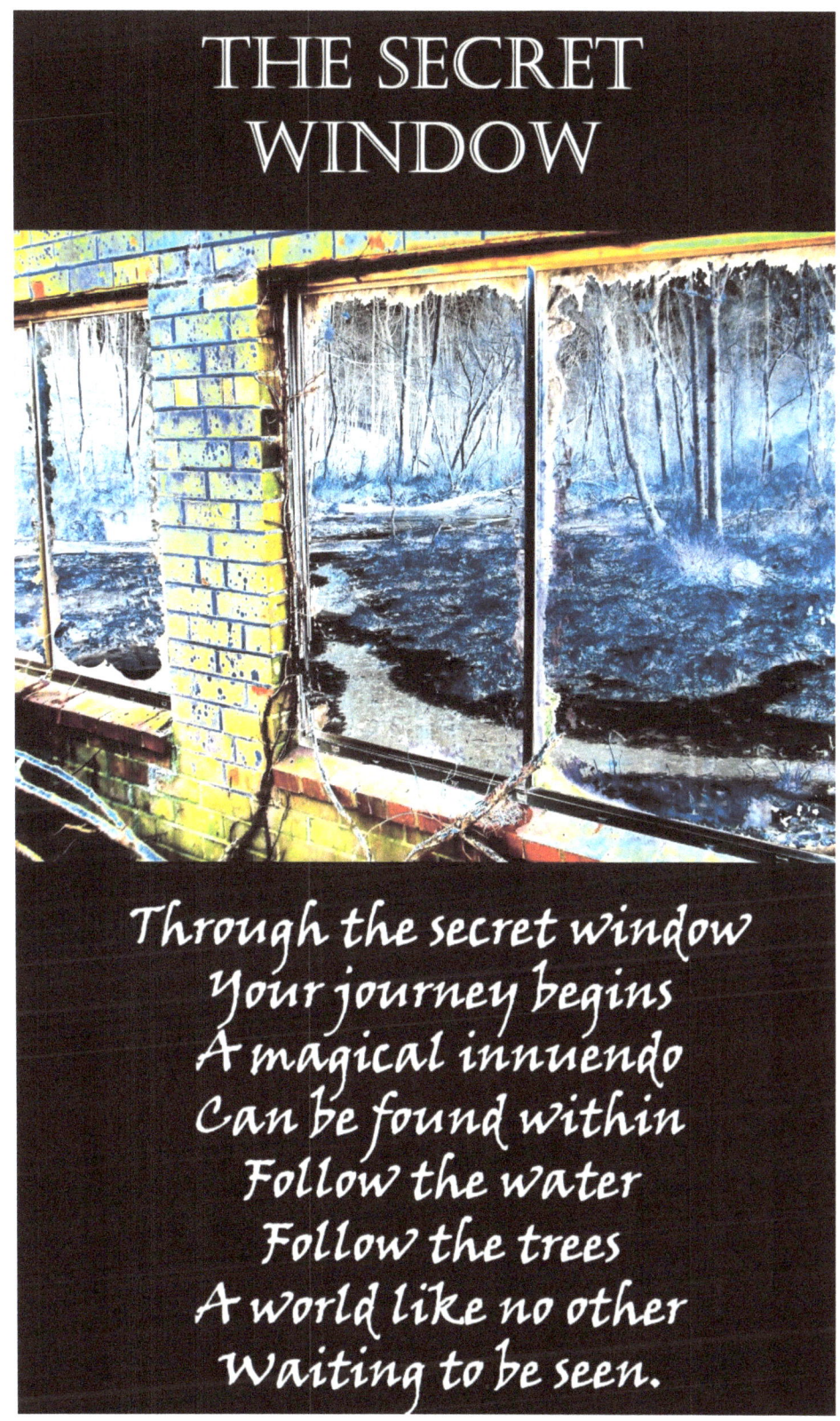

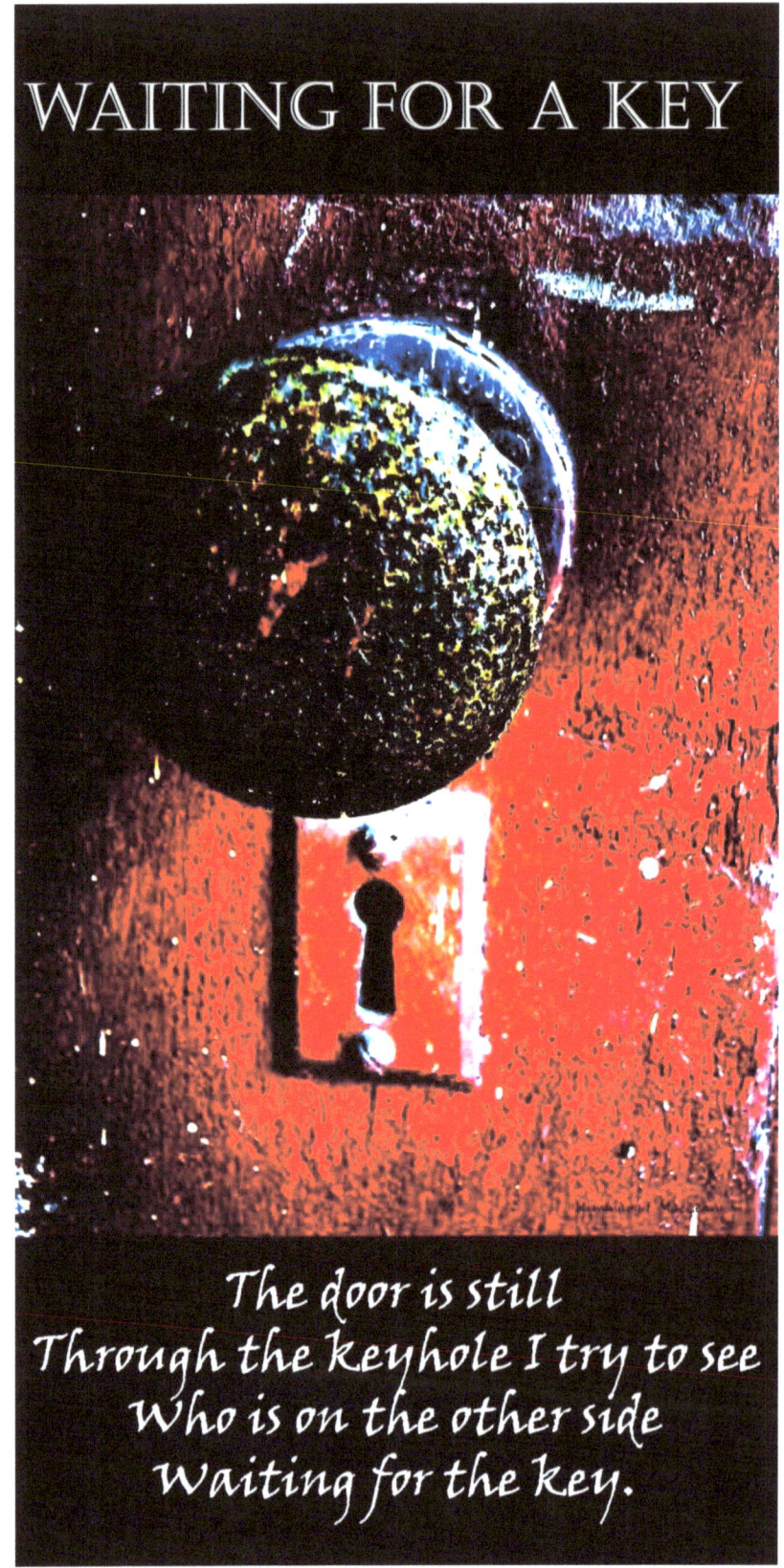

WHAT I SAW

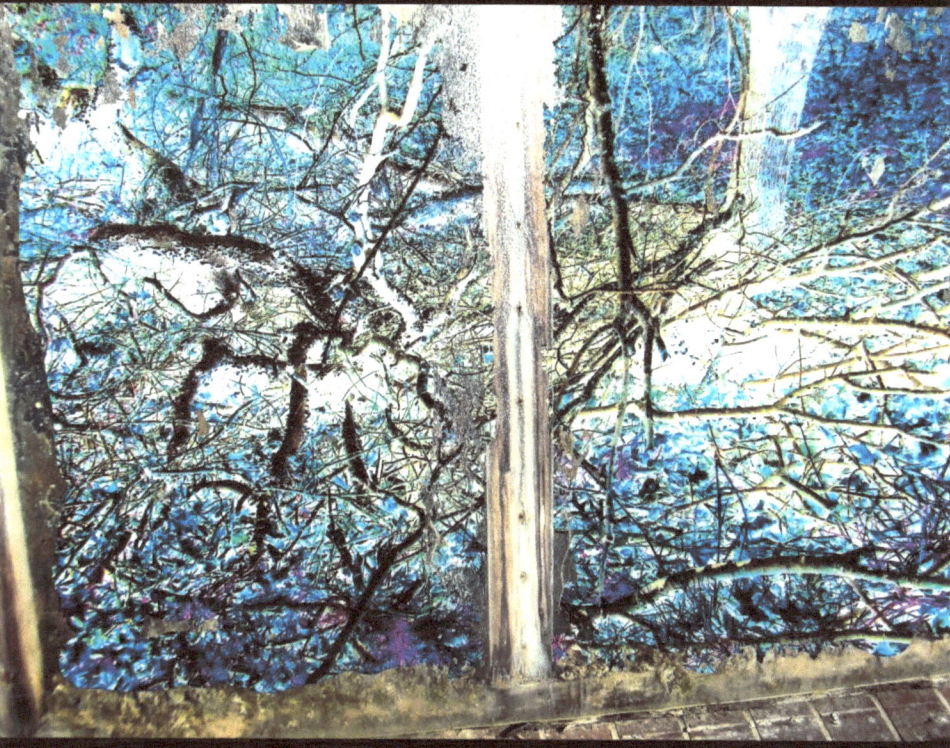

Building of brick
Strong vines shattered
The windows so thick

A forest without law
Chaotic and deranged
That is what I saw

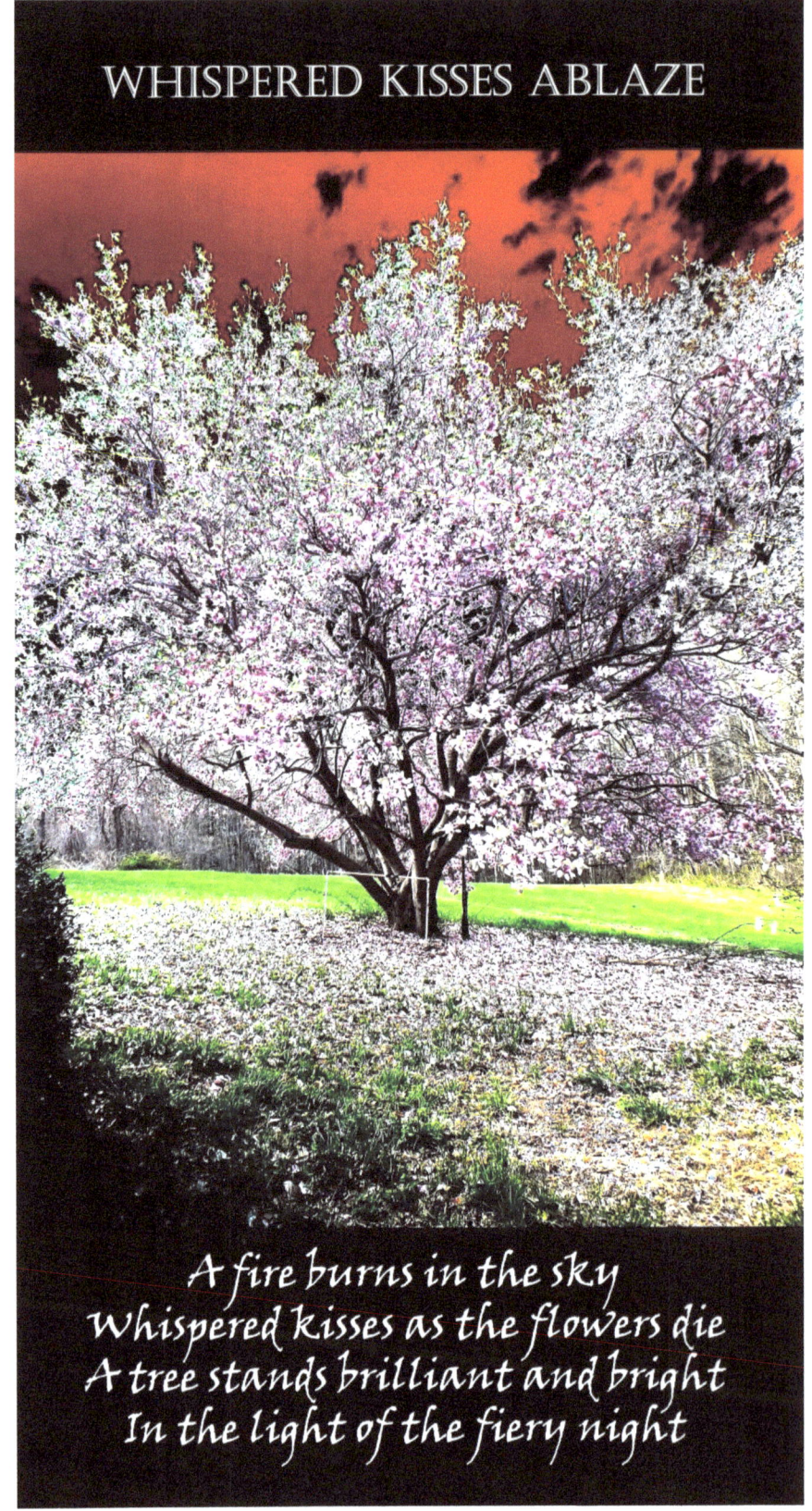

WILDFLOWER TUTU

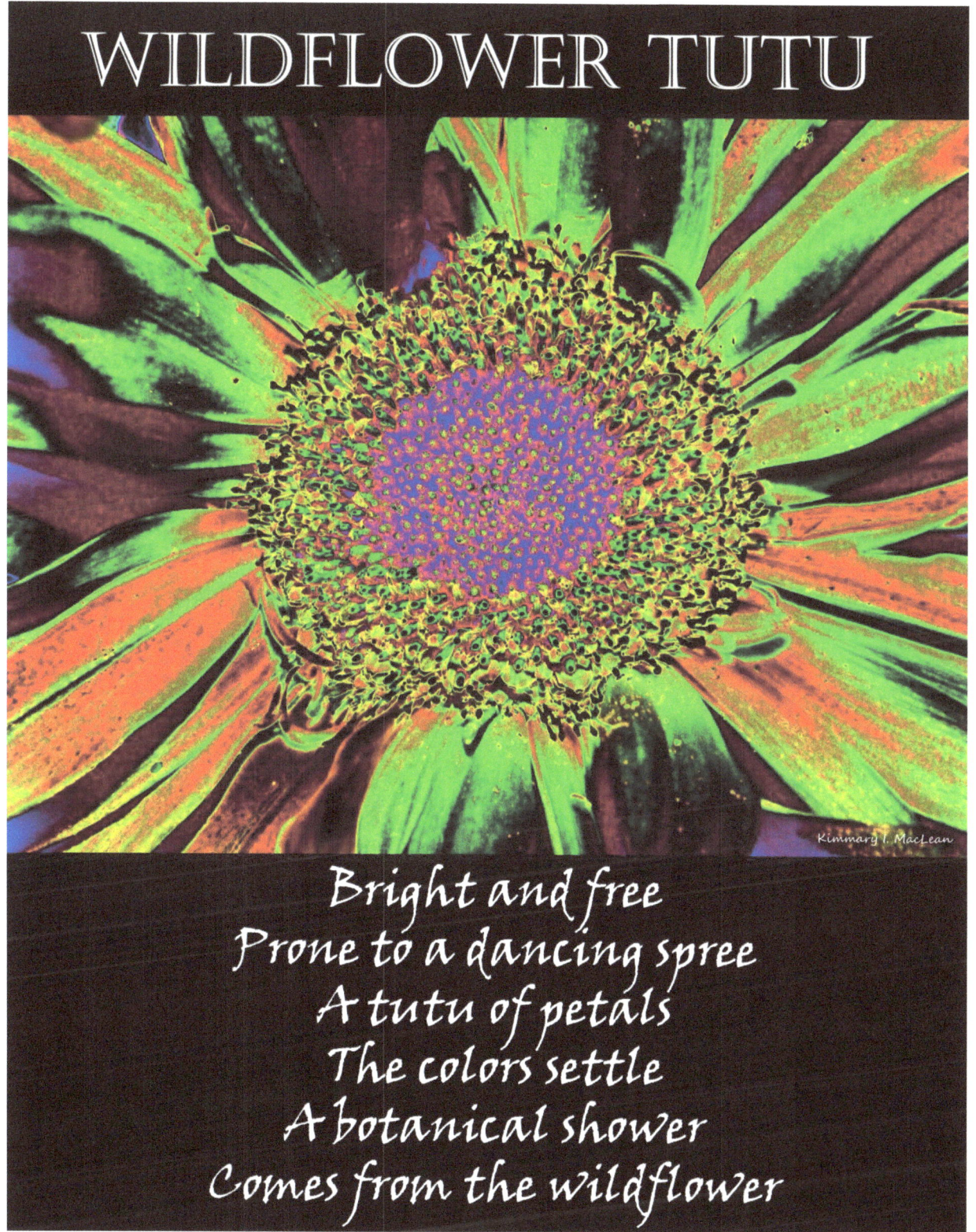

Bright and free
Prone to a dancing spree
A tutu of petals
The colors settle
A botanical shower
Comes from the wildflower

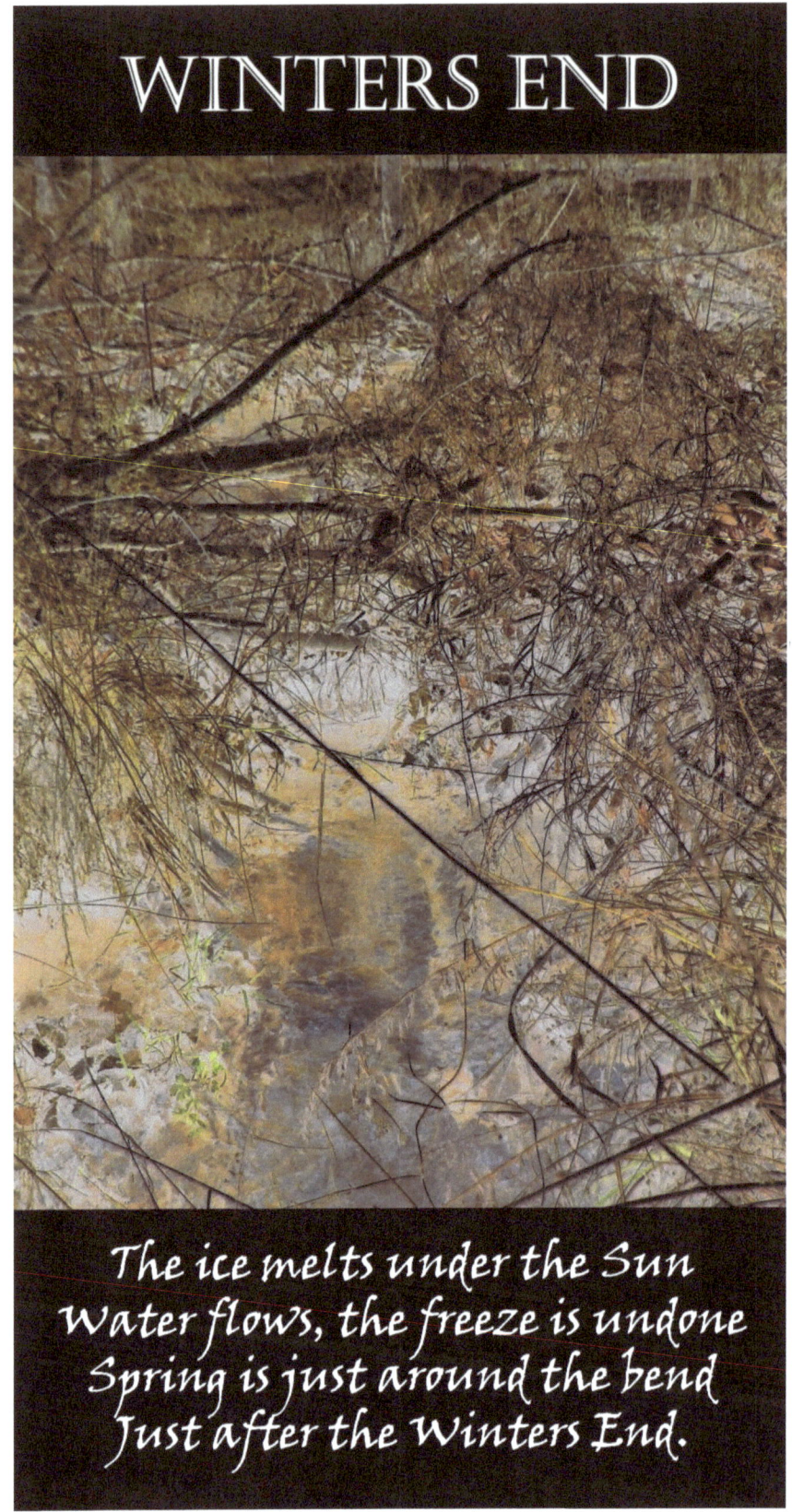

ABOUT THE AUTHOR

Kimmary I. MacLean is an artist, a dancer, a ballet teacher, and an author. She is also a parent of two beautiful children, whom she homeschools. Kimmary has a great love of nature and animals. Here is her artistic biography.

Art represents something different for each person. For some it is a valuable piece of merchandise, some feel as though the artwork displays their innermost feelings, some admire the skill of the artist because it is not something they can achieve, and some simply enjoy the colors. In the end art means something to all of us, what it means is our decision.

As a child I would spend hours perfecting my drawings, as a teenager I would hide in my room painting, and as an adult my version of a vacation is sketching or painting in a new place. I come from a family of artists, musicians, and dancers. My Great Great Grandfather was the interior designer for the Sultan's Palace in Istanbul, later commissioned for the World's Fair in St. Louis, Missouri. My Great Grandmother was an artist, who painted, sculpted, and drew for the love of it. My grandfather was a professional violinist. My grandmother founded the National Ballet, Inc. in Maryland. My father was a talented painter and can pick out every note and instrument in any piece of music. My mother was a great dancer and is still a great

teacher and choreographer for the National Ballet, Inc. My sister is a wonderful flutist. I have played the piano, clarinet, and oboe. I teach ballet. I paint. I draw. I love art in all forms.

I am a Maryland artist specializing in nature and animals. I work in several mediums including painting, drawing, digital, and photography.

A graduate of the University of Maryland, College Park, I have two Bachelor degrees. One degree is in Art Studio and the other is in Accounting. I am also a certified teacher in the Cecchetti Method of ballet through the Cecchetti Council of America.

Today, I can be found painting, drawing, photographing, or working digitally on the computer, as well as, teaching ballet at the National Ballet Institute for the Arts. My artwork can be found on Imagekind, Fine Art America, Artist Rising, and RedBubble.

In addition to 'Excursion: A Book of Art and Poems' I have also written two children's books, 'A Caterpillar Goes for A Walk' and 'One Squirrel in A Tree…'

www.ingramcontent.com/pod-product-compliance
Lightning Source LLC
Chambersburg PA
CBHW051100180526
45172CB00002B/716